LISMORE

EUGENE F. DENNIS

The
History
Press
Ireland

For my parents for chances given and half taken, and L. Walsh, who willingly gave help on request and encouragement at 'feel-like-packing-it-in times'. *Céad míle buíochas.*

First published 2011

The History Press Ireland
119 Lower Baggot Street
Dublin 2
Ireland
www.thehistorypress.ie

© Eugene F. Dennis, 2011

The right of Eugene F. Dennis to be identified as the Author
of this work has been asserted in accordance with the
Copyrights, Designs and Patents Act 1988.

British Library Cataloguing in Publication Data.
A catalogue record for this book is available from the British Library.

ISBN 978 1 84588 690 5

Typesetting and origination by The History Press
Printed in Great Britain

CONTENTS

ACKNOWLEDGEMENTS

Most non-fiction books depend on a co-operative effort; a book of vintage photos more than most. A sentiment such as 'all for the village' may have less motivating power now than when localities had more coherence. While the current mood of pessimism is no help, enough people were motivated to share their photographic treasures. These are thanked if not individually as it would be invidious to do so. Sometimes just giving information can be enough; it shows people appreciate, not only the overall objective (which is heritage conservation) but the implied objective about demonstrating that Lismore and Lismoreiana lie on a continuum of history and that they are denizens of 'no mean city' and hence no mean citizens themselves. In brief, being proud Lismoreians with a basis for that pride. This identity development idea is already there, even if commercially oriented, in the Lismore Development Association.

Of exceptional help were: Frank Mason, a brilliant correspondent; John C. Noonan, our resident artist and cartoonist; Sham Power, a one-man Shroughian search engine, and Pat Foley a well of local wisdom; also Peter Dowd, Ann O'Donnell, John McGrath and Alice O'Donoghue of the Heritage Centre. Greatly thanked and remembered are the countless anonymous photographers down the decades. These didn't merely press buttons; they set up and exploited opportunities which is, effectively, a definition of photography in any era. Sources additional to these are thanked: *Ireland: Photographs 1840-1930*, compiled by Seán Sexton; *Ballysaggart GAA Remembers* (1984); *Cappoquin: Light of Other Days*, Heritage Group (2008); *Glimpses of Glencairn* by Sr V.G. Kelly (2005); Lismore Papers, National Library of Ireland; the Heritage Council, and local newspapers.

While every effort has been made to avoid mistakes, the author takes the blame for any occurring. Much of what is recorded in the book has now gone, however the response to the first book, of which this is a continuation, shows that it is not forgotten, Roland Barthes notes that 'a photo asserts to the fact that someone/something did exist'. Let this book assert to the fact that a prospector, with a lot of help, was privileged to dig for that someone/something, barren ground often yielding more fruitful results than expected. John McGahern used to say that a writer creates nothing, s/he merely assembles memories; similarly, the author of a photograph collection creates nothing; s/he merely assembles mementos. However, these mementos represent a cultural artefact which gives satisfaction and is educative in a broad sense and accordingly identity enhancing. *Míle buíochas* for that, surely!

OUR PHOTOGRAPHIC HERITAGE: PROJECT SMILE

The great photographer Cartier-Bresson defined photography as the art of the decisive moment. It is a modern, professional definition and hardly applicable to the early slow-lens and long (seven-minutes!) exposures. Most of the photos in this book are by amateur, anonymous photographers; they are essentially 'the people's photos'. In France in 1839, Louis Daguerre launched the first commercial camera, now called the Giroux Daguerreotype. The Lismoreian, Francis Currey, fascinated by the development of photography, set up a studio in Lismore Castle in the 1840s. The next milestone in photography was the Kodak camera of 1888 and then the Brownie of 1900, which sold for $1. The latter two cameras made photography a popular pastime, be it by individuals or studios.

Our amateur photographers were unlikely to be practising 'decisive moment' art; rather snapping something to find out how it looked when snapped, or creating an alternative 'artwork' by merely pressing a button. They saw the camera as an honest medium, unambiguous yet challenging – perhaps as a wonder substitute for inarticulacy. As Lewis Hine noted, 'If I could tell the story in words I wouldn't need to lug around a camera.' Curiosity, also, would have been a motivation, but we can credit them, too, with a sense of history, hence seizing on a convenient system to visually edit the passing scene and hold it for posterity. It is said that journalism is the first draft of history; let us add that photography may be its final, and indeed finest, illustrator.

Even when and if old images *explain* little, they are inexhaustible invitations to deduce, suggest and fantasise. In this sense, old photos not only capture the way we were but suggest the way we might've been; as such, they possess, a moral dimension.

Photography is the most accessible of the mimetic arts and perhaps, if not too fanciful, a kind of *lingua franca* which expresses itself and is shared most elegantly in a book. Old images help us to recall and remember, and, as the Jews observe, to remember is to live again. An image seen is worth a thousand references to it. An image set out is a tangible act of heritage conservation. It is, in our case, for the aggrandisement of old Lismoreians, and the human virtue of memorialising 'Lismoreania' and those who once trod the ancient crookedness of the town's streets and the scenic byways of its countryside. Finally, our photographic vignettes of times past provide a reassuring summary of a wholesome innocence. Looking at small occasions and ordinary people through respectful lenses, we suspend our belief, perhaps even our hard-nosed scepticism, and enter a nirvana of nostalgic desire.

In our first Lismore photographs book we typified photographs as part of the hidden heritage of Ireland, hence, vulnerable to loss, be it through neglect, deterioration, etc. The editor's remote motivation in collecting vintage photographs lay in being complicit as a late teenager in the wanton disposal of a box of old photos. It was, in effect, a desire to square a moral circle. The immediate motivation was the aforesaid contemplation of loss. Accordingly, in 2003, the editor set up Project SMILE, an acronym for 'snaps, momentous and immemorial of Lismore and environs'. The aim was to collect and publish a book of vintage Lismore images. This was duly done, plus scores of images were also reproduced in two Lismore millennial journals.

Collection is a process. The end result is related to the duration and intensity of the process. The editor was concerned about the representativeness, an effect which might be achieved, in some form, by accessing the twin objective of families and townlands. People have the prerogative to ignore their native place's cry for help. One hopes it's a prerogative people will choose not to exercise. This isn't always the case but often persistence, even cajolery, but above all patience can help. A small minority may actually frustrate one's efforts, for example by not supplying addresses or more wilfully by claiming spurious copyright or most bizarrely by a syndrome we might call 'uncertain parish identification'. In brief, collecting is not only a process; it is an art as well – a crude art rather than a fine one.

In our PR material for Project SMILE, people were asked to undertake one hour's search in order to uncover an eternity of memories. People were reminded that photos remember, people forget. Potential donors were advised that portraits of people in a book more endurably memorialise those people than gravestones – that the latter always eventually crumble. A dictum was advanced: by marrying images to near-forgotten names and phenomena, one completes a memorialising process. All part of the cajolery of collecting, if harmless.

Overall, it is reasonable to say that consolidating a representative sample of Lismore's photographic heritage is timely: timely because increasingly, modern life seems evermore a ferocious whirligig where a kind of functional autism is becoming an acceptable state of mind. Lismore's modern slogan is, 'Where the Past is always Present'. This is a humane slogan in an age of globalisation (a phenomenon sadly based upon getting rid of the immemorial). However, slogans are empty if not supported by recurrent action on the ground.

Finally, it was felt that all photos used should at least be competent. This aim was set aside only in a few cases where the images were historic and/or rare.

ABOUT THE AUTHOR

Having taught for many years, Eugene Dennis retrained as a journalist. He edited the *Dublin Freelance*, working for *The Irish Times*, *The Irish Press* and other publications. He scripted for *Sunday Miscellany* in the 1980s, wrote three educational monographs and two well-received poetry collections. Eugene has a special fondness for the short story and has been a finalist in two competitions. He found the editing of the West Waterford millennial trilogy (one of which has yet to be completed) particularly gratifying. This is Dennis's second book of vintage Lismore photos, the first now considered a classic of the genre. He lives in Cork.

INTRODUCTION

LISMORE TOWN IN CONTEXT

Irish towns in the past symbolised little in regard to Irish identity. Political leaders and writers in the 'new' independent Ireland have tended to emphasise rurality. Perhaps Lismore was lucky, even if once bearing the soubriquet 'Citie of St Carthage', to be small enough to be contained within this idea of rurality. The bias against the undoubted equal greatness of towns is hard to explain and may be related to our colonial history, and so it is better left to historians. Clearly too, recent trends towards urbanisation has, perforce, restored a balance of focus on towns. This trend is welcome. This book focuses more on Lismore parish than on the town of Lismore.

THE RISE AND FALL OF LISMORE

Images of Ireland: Lismore (2005) outlined a brief history of Lismore. Lismore has many histories but we can't discount the known facts. These may be gleaned from Lewis's *Lismore, a Market and Post Town, a Parish, the Head of a Union and the Seat of a Diocese.* Lewis wrote this in the late 1830s. But we know there were proto towns prior to the coming of the Anglo-Normans. Lismore was one of these. Lismore's old name, Dunsginne, suggests a pre-monastic origin, though St Carthage in the seventh century is acknowledged as founder. Its monastic history was particularly glorious. Boastful Lismoreians are wont to quote, 'When Oxford was a cowpath Lismore was a flourishing university city!' It was repeatedly plundered by the Danes, burned by the Ossorians in 978, destroyed by accidental fire in 1095 and in the twelfth century suffered much conflagration. And then came Henry II to bestow upon Lismore the dubious honour of being the place where Anglo-Norman rule was first established in Ireland, when the chiefs, bishops and abbots of Munster swore allegiance to him and gave Henry a charter confirming the kingdom of Ireland his and his heirs' forever.

It is acknowledged now that Christian monasteries performed the functions of incipient towns. This was an indirect effect of Roman urban culture, where a town was both a cult site and a marketplace. The Viking invasions consolidated towns as cultural and economic centres. Then came the crucial Town Charters, which granted law and self-government to towns. King James I granted Lismore a charter in 1613. It remained thus until the Union in 1801. Rebellion, plantation and domestic warfare in the seventeenth century touched Lismore directly and indirectly. For example, insurgents in 1643 killed sixty Lismoreians and burned most of the cottages, and in 1645 the castle was reduced to a ruin by Lord Castlehaven and the town became 'a neglected village, consisting only of a few cabins'.

9

RECOVERY AND RENEWAL IN THE NINETEENTH CENTURY

A vitally important mark of many Irish towns in the late eighteenth and nineteenth centuries was improving interventions by landlords, this notwithstanding the overall evil of landlordism and the discontinuities of famine. This was very much the experience in Lismore, especially in the case of the Bachelor Duke in the nineteenth century who, with the brilliant Joseph Paxton, was largely responsible for Lismore as we now know it. The inhabitants of the townland of Ballysaggart know differently in the case of the notorious landlord Kiely Ussher, of course. A final feature worth mentioning of Irish towns in the nineteenth century was the resurgence of Catholicism as a formal institutional influence, due perhaps to the Catholic Relief Act of 1783. This showed itself in the building of neo-Gothic Cathedrals and the spread of indigenous teaching orders. Lismore perfectly followed this trend.

LISMORE IN MODERN TIMES

Lismore certainly has had a chequered history; once an inviolable Episcopal city, then a ducal appendage and, in 2004, Ireland's 'Tidiest Town'. The place escaped opprobrium despite being 'the Home' of Anglo-Norman (British) rule in Ireland. A contrary place perhaps: contrary in its unique ability to accommodate two seemingly different traditions – Castle English and Native Irish, Protestant and Catholic, town and country.

Lismore today is self-confident and at ease with itself. The Castle and visiting British royalty may attract some criticism and imputations of West Britishness. Most Lismoreians are happy that any royal visits are moderated by freely protesting republicans who all get invited later to the Duke's party. To exemplify further, two old Cappoquin ladies wished to go on a drive recently, one suggesting Lismore. The other snapped, 'Oh no, not there – I've no sterling on me!' Lismoreians take no notice of that, in fact, they love it. Lismore Parish: a place for all seasons and any reason. *Go maire sé go deo*.

1

EARLY IMAGES

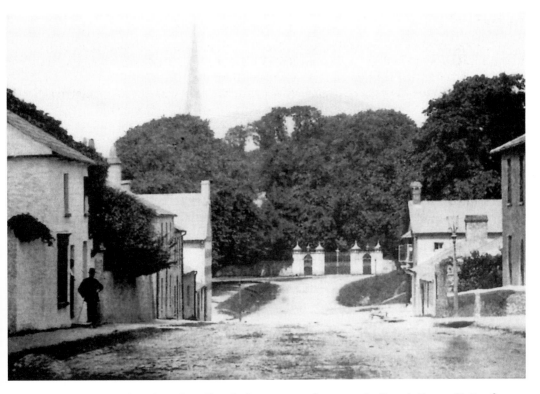

A view of the North and South Mall in the late nineteenth century by Francis Currey. Notice the gaslight on right and the then one-storey house below it, which later became the post office when it moved from Main Street. It is now Willie and Laura Roche's home.

'Lismore'

A meeting of bright streams and valleys green;
Of healthy precipice; umbrageous glade;
Dark, dimpling eddies, 'neath bird-haunted shade;
White torrents gushing splintered rocks between;
With winding woodland roads; and dimly seen
Through the deep dell, 'ere hazy sunset fade,
Castle, and spire, and bridge, in gold arrayed;
While o'er the deepening mist of the ravine
The perspective of mountain looms afar.
Such was our Raleigh's home – and here his eye
Drank deep of nature's wild variety,
Feeding on hopes and dreams! From the world's war
Retired, he dwelt; nor deemed how soon his star
Should set, dishonoured, in a bloody sea!

Sir Aubrey de Vere (1788-1846)

Mórán siúlta ar thóir na brionglóide
Mistéir an domhain go léir a chloí
Níos fearr an leathar a chaitheamh sa bhaile
Tá an domhan go léir i Lios Mór mo chroí

To travel far in pursuit of dreamland
The world's mysteries to dissolve with ease
But better far to cease from travel
The world's at home in Lismore machree

E.F. Dennis

One of the earliest photographic studios in Ireland was set up by Francis Currey in Lismore Castle in the late 1840s. We present here a few of Currey's works. Currey is considered a fine technician, though his portraits are sometimes stagy. A stagy photo reflects the photographer's attitude. A photo itself doesn't say anything definite, but nor is it a lie. The camera is said not to lie because it claims nothing.

As noted in earlier remarks, the Kodak 'box' camera became popular in the USA after its introduction in 1888; its influence here was peripheral. After Currey, little occurred in the Lismore area until Lawrence appeared in the early twentieth century. Eastman's Brownie Box camera of 1900 became popular here quickly enough. Studios and professional photographers remained long time in the ascendant. For the purposes of our book, we consider images snapped well into the twentieth century to be early images. Lismoreians often stepped into Horgan's studio in Youghal to get photographed if money was flush; the discerning would save towards a portrait. Most of our photos are the 'people's photos' and are as much part of the hidden Ireland as the hidden Ireland of literature that Daniel Corkery wrote about. These are hidden treasures whose dividend, gratefulness, will continue to be paid.

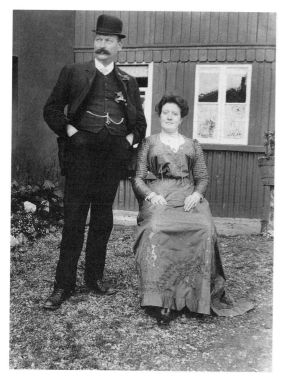

Pat and Kate Hale snapped in 1890 at the back of their hotel in the South Mall, which later became the Commercial Hotel. Kate was a bit of an entrepreneur – she was a butter buyer in neighbouring towns. John O'Donnell, who was related to the Hales, took over the hotel on returning from South Africa.

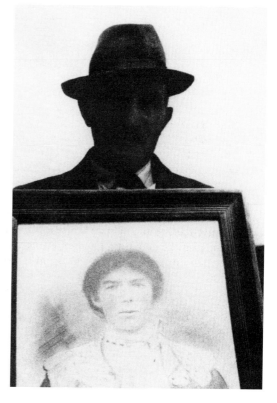

This 'double' photo dates both from the 1890s and the 1940s. Mick 'The Bird' O'Brien of Botany holds a portrait of his mother, who was born just post-famine. Her portrait suggests above all nobility of character and likely a home couturier of discernment.

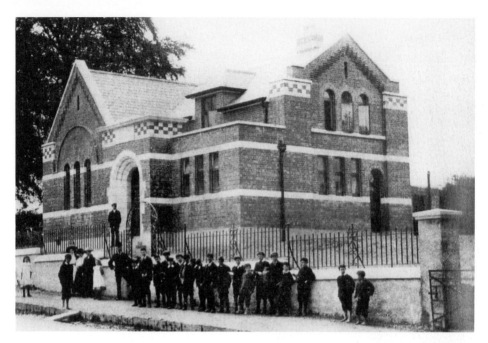

Lismore Carnegie Free Library on opening day, 15 August 1910. The Duke donated the site after assurances that the library would not be used for political/religious purposes. Built by T. O'Mahoney of Fermoy in the Irish Romanesque style, it served as Library HQ for years. It was given a makeover and reopened in May 1991, and later that year a bust of Robert Boyle by John Coll was unveiled by President Mary Robinson.

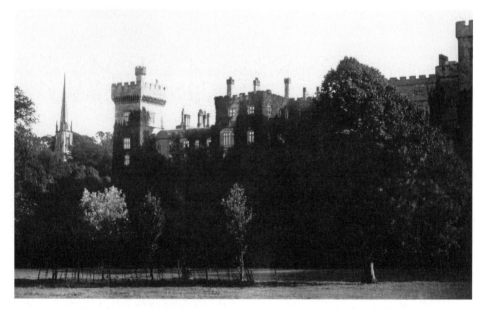

This view of the Castle and Cathedral spire is from the Lawrence Collection (1904). It bucks the clichéd representations of Lismore's most iconic view. Both buildings are now illuminated, hence darkness, too, is their ally as they flaunt their beauty.

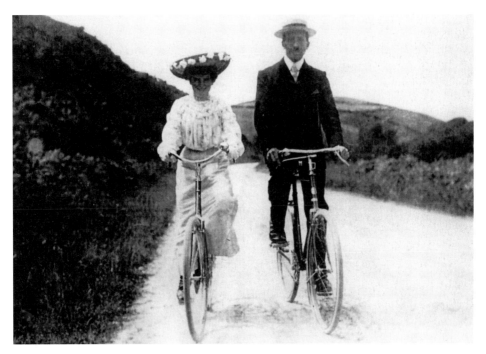

This was, in fact, a first tryst between Margaret Higgins and Dan Lawton, who married in 1905. Dan was an RIC Sergeant in Ballyduff and, perhaps surprisingly, secured the important town clerkship in Lismore. Dan was, it seems, long-time disaffected due to the RIC's dastardly and 'uncivil' role, and was held by some to have not too diligently prosecuted the perceived transgressions of the freedom fighters. Also, he had married into a republican family. That love conquers all can certainly include revolutionary movements. Our snap was taken in Portlaw, where they drive on the right!

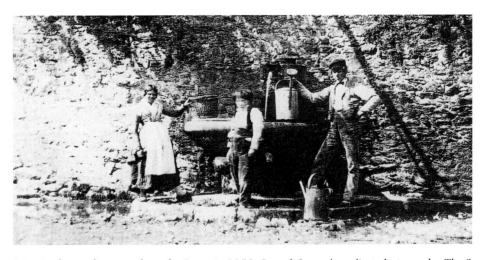

Bringing home the water from the Spout in 1853. One of Currey's earliest photographs. The Spout has been a Lismore landmark for near on two centuries. As a local poem has it, 'The Spout, in its cold vestibule rinsing the locale in guttural spouting/An eternal flood-flame to the famine dead/ Who lie forgotten in alluvial mud behind the laurel kissed walls'.

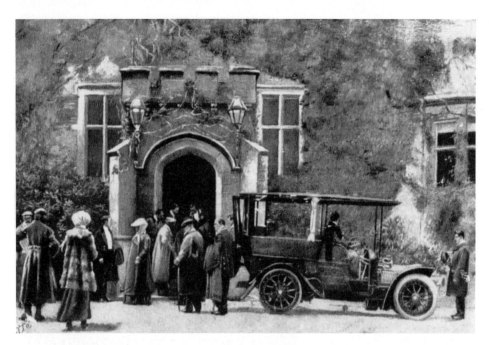

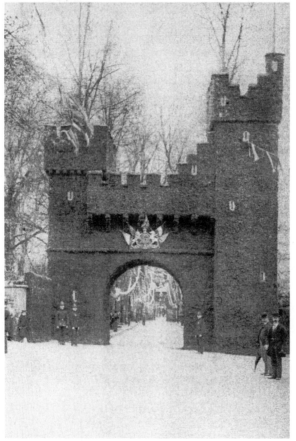

His Majesty King Edward VII (pictured in the middle, with cane) and Queen Elizabth (wearing the tied-on hat) leaving Lismore Castle for a drive in May 1904. This photo was created from a postcard sent from Preston in the UK on 23 March 1905 to the Behegan family in Botany.

A mock archway to honour King Edward VII's Lismore visit, May 1904. Lismore Dramatic Society are said to have helped in its creation. If it betrayed perhaps sycophancy it also demonstrated ingenuity and that the royalty thing was, in the upshot, nothing more than showbiz.

The great Blackwater Rambler
'footie star' William 'Garret' Hogan
with his son William at Castleview,
c. 1904. Wee William became
father of musician Billy Hogan. The
preppy young William seems to be
demanding a reversal of roles with
the photographer, '...yerra relax, Sir,
and smile, this likeness takin' is only
a bit o' Lucy's rock!'

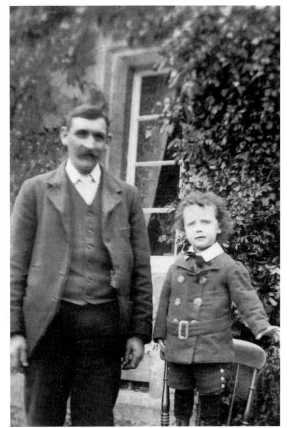

An old stone whiskey jar customised
a century ago for Meade's pub at
the corner of Ferry Lane and Main
Street. The premises was later a
select drapery and held by old Irish
freedom fighter Eddie Nugent. It is
now Mari Mina's chemist shop and
held by the Egyptians, the Hannas.

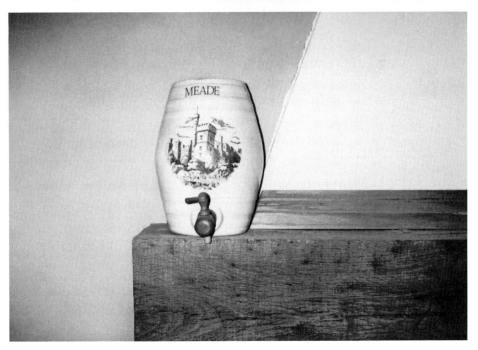

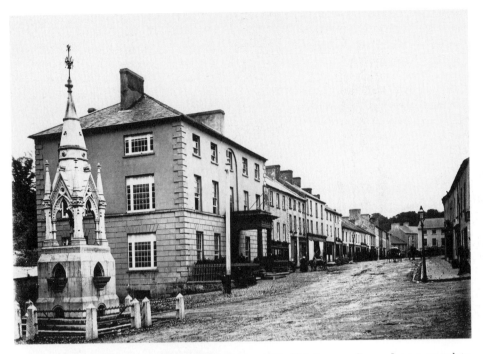

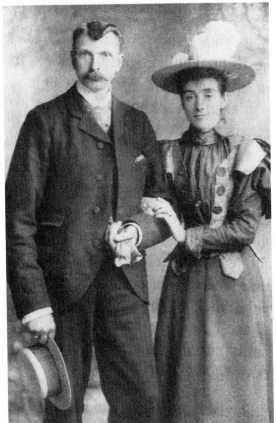

This is an earlier and more complete shot of the Main Street than the iconic photograph published in *Images of Lismore* (2005), p.22. Note the bollard-type monument surrounds; the cobbled pathway to the left which merges with the crude street surfacing, though paved and raised to the right; the one-block, undeveloped hotel and the Red House still to emerge with its characteristic mock balcony and red decor.

An intriguing wedding portrait from 1896 of the O'Connors of Chapel Place. They are the maternal grandparents of Frank Mason (son of Garda Michael Mason). The groom sports an early buzz cut complemented by a boater, conveying, perhaps, a showbiz flair. Indeed a daughter, Eileen, became a pianist at the Mall Cinema and the other children were quite theatrical.

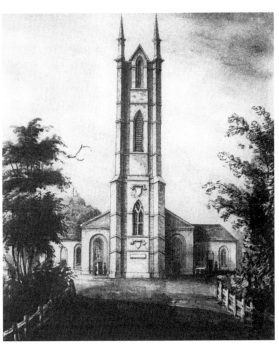

A Robert Armstrong image of the old Catholic church, 1842. In an unfussy, Gothic style, the three-storey façade of which, with it chancel-type windows and canopied decorations, look quite elegant and balanced. It is reminiscent of St Joseph's of Berkeley Road, Dublin and the Holy Redeemer in Bray, the latter ruined by a modern façade. Lismore church escaped this tedious modernism though clearly not the unwarranted need to replace it. Its rebuilding on the same site in 1884 was likely a statement of indomitability and an envy trophy in regard to the pre-eminence of the Church of Ireland Cathedral.

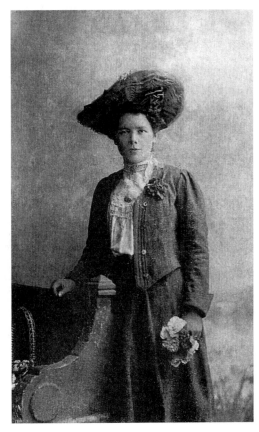

Portrait of Laura Whelan of Mayfield, *c.* 1905. This is a photo that makes photographic conservation worthwhile. What a lady, what an ensemble, but *mon dieu* what a lid!

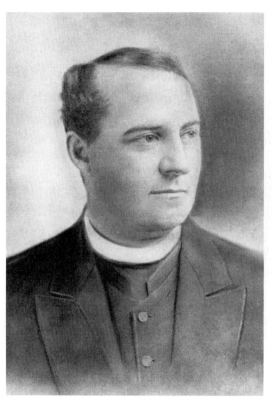

Born in Ballyanchor in 1884, Fr M. Carthage O'Farrell was a priest of the Archdiocese of New York. As pastor of St Teresa's church in Lower Manhattan, he administered one of the largest parishes in the city, which was made up of Irish immigrants who entered the US through nearby Ellis Island. He visited his native Lismore in 1884 to celebrate the first Mass in the newly restored St Carthage's church. A promoter of education, he was instrumental in the founding of the College of New Rochelle, and he was the first President of that University from 1904 until his death in 1918.

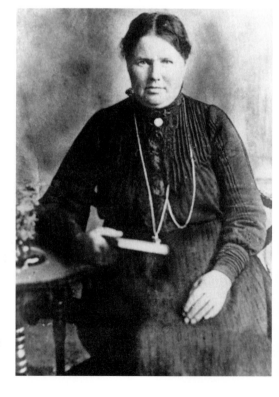

Portrait of Ellen Power of Shrough from 1890. Ellen was a Cuffe of Bishopstown and mother of Commandant William Power. She was the grandmother of Sham and Maurice Power, who still live in Shrough.

John Noonan, grandfather of John Noonan, marine artist, and his daughter Eileen snapped in the garden of their Blackwater Vale Hotel (now Roche's) in the late nineteenth century. John died in 1906 and sadly Eileen died in her late teens from tuberculosis. Both are buried in the old cemetery on Chapel Street.

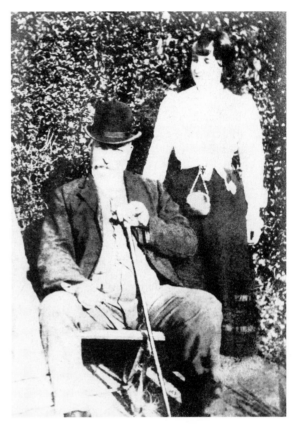

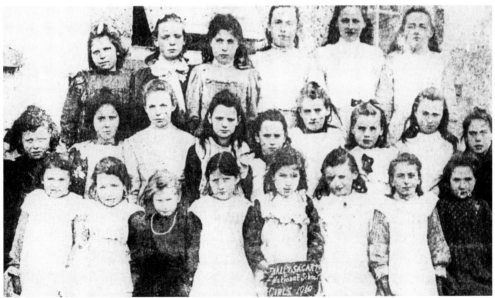

Ballysaggart National schoolgirls of 1910. The children look well turned out, handsome and not lacking in vitamins. Not knowing the children's names may be regrettable, but we can use our imaginations to contemplate their once beautiful lives.

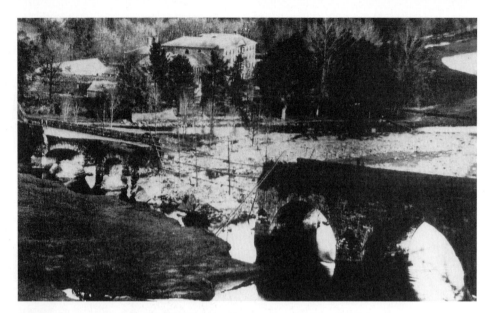

This image by Currey captures the devastation caused to Lismore Bridge by the great floods of 1853, when a couple of arches were swept away. After *c.* 1750, theory-trained engineers and architects supplanted stonemasons at bridge-building. Lismore Bridge, built by Ivory in 1775, was revolutionary in that it had segmental arches. This allowed greater span and Lismore Bridge was the first in Ireland to reach thirty metres. 'Did Ivory's grasp exceed his reach?', a supplanted stonemason might well ask. In the background we see one of Ireland's early industrial estates looking detached and invulnerable in the surrounding flood chaos.

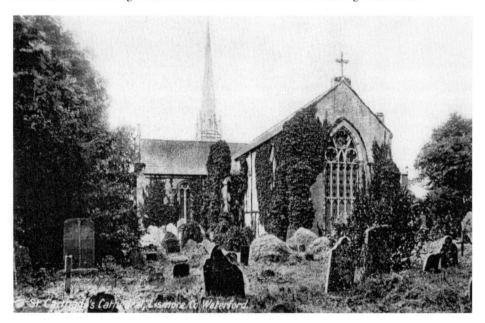

An unusual view of St Carthage's Church of Ireland Cathedral from the nineteenth century. Note the ivy; once seen as a beauteous adornment but later removed due to its corrosive nature. The headstones, man's stony page of death, lend a mystic quality to a venerable site.

2

WORK AND LIVING

A charming snap taken at Tom and Elsie Doocey's home in Fernville on 21 August 1952. Back
row, left to right: Mrs Anna Bransfield, Mrs Mary Canning, Mrs Kate Behegan, Mrs Ellen O'Brien
and Mrs Mamie Scanlan (née Keating). Middle: Mrs M Scannell. Front: Margaret Scannell (aunt
of Elsie's and once housekeeper at Lady Godfrey's), Mrs Elsie Doocey (née O'Brien) and Mrs
Madge Geoghegan (the Geoghegans went to the US *c*. 1960 with sons Joe and Anthony. Anthony
was tragically drowned in a bizarre reservoir accident). The occasion was the saying of Mass by
Monsignor O'Brien.

Out of the land where I was born
Come sad-faced men, for whom the thorn
Grows to make bludgeon, not to bless
Earth with its pallid comeliness.

Through every aching tree they hear
A keen for which I strain my ear.
At times I can but dimly know
The hardship of the way they go.

But on a Fair Day in the town,
God! – they can put the whiskey down!
I see the pain, the lone surprise
And sorrow in the cattle's eyes.

If woe be for a time cast out.
Where may its clouds not drift about?
From man to beast the misery
Escapes when he is drunk, maybe.

Temple Lane

Lismore's prowess in the religious, education and literary fields overshadow its achievement in the commercial/industrial arena. As early as the seventeenth century, mining was carried on in Deer park and Lismore was a major player in the industrial drive of Richard Boyle. Ireland in pre-medieval days could boast sublime achievements like the Book of Kells and the Ardagh Chalice, and of course our own Lismore Crozier. Claims are made that the first industrial revolution occurred at Mount Gabriel in County Cork, where smelting was discovered.

The Castle, great houses, farming and shops were major sources of employment through several centuries. An extensive Castle salmon fishery and hatchery business saw fish exported to Britain, and the canal afforded commerce with Youghal port. There were flour and clog mills in Ballyin, Paxman's butter factory and Lismore Gas and Coke Company at Ballyrafter, and a nicotine factory, which was viable till the late 1930s.

The idea of economies of scale became the enemy of the self-reliance and the self-sufficiency of small Irish towns. Enterprises like forges and mills, and trades such as bakeries, coopers, tailors, boot-makers, nailers and so on, and even the railways collapsed like dominoes. The collapse brought mass emigration. Then there was the Lemass regeneration, which meant little to small places like Lismore. We now hear terms like 'import substitution', which is nothing but jargon for the old self-reliance and the economic philosophy of no less a man than Arthur Griffith. Lismore's commercial past is something to celebrate in order that it might be emulated.

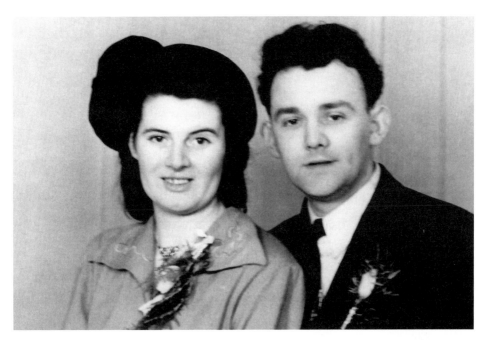

Billy Hogan and Kathleen Crowley on their wedding day, 23 January 1952. They were married in Lismore by Fr Denis McGrath, with Pete Gillen as best man. The reception was held in O'Donnell's Commercial Hotel in South Mall. They are still a handsome couple. Like the poem, 'And there is healing in old trees/Old streets a glamour hold/Why may not I as well as these/Grow lovely growing old!' The Hogans have.

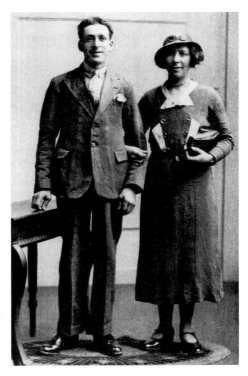

Wedding photo of John O'Brien of Owbeg and Kate (Cathy) Coughlan of Seemochuda who were married in Lismore in 1935. The couple met at the Owbeg stage. They had two attractive daughters, Margaret and Anne. Margaret still lives in Chapel Street, Anne emigrated.

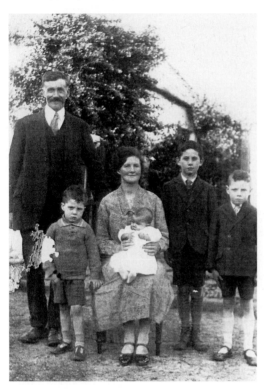

O'Donnell abú, Mayfield, 1930. Eugene O'Donnell and Mrs Alice O'Donnell (née Broderick, Monatarive) with their new daughter Mary after her christening. The boys, left to right, are: Eoghan, Ben and Michael. Mary married Garda P.J. McInerney, a redoubtable Clareman. O'Donnell's was a model farm in its heyday, so well captured by Jim Ballantyne in his great Lismore book.

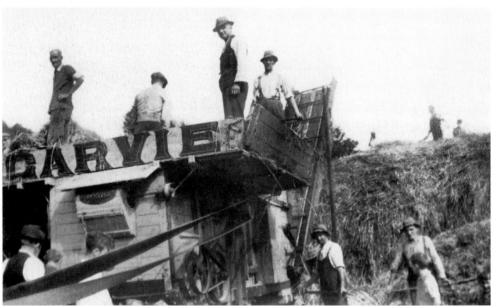

Threshing at Jerry O'Brien's of Monamon in 1949. On board the thresher we see from left to right: Johnny Poole, forever the sheaf cutter, probably singing 'I'm the Carter's Lad' or 'Asleep in the Deep', his habitual 'livealong' tunes; Kevin Lineen, with back to camera; the thresher owner, Jimmy Heelan of Monamon, and Bill Buckley in the hat. Directly under Bill are Jerry O'Brien, Pad Scanlon of Monamon and young Jimmy O'Brien. The hatted man to the left is Jerry Fraher of Dungarvan.

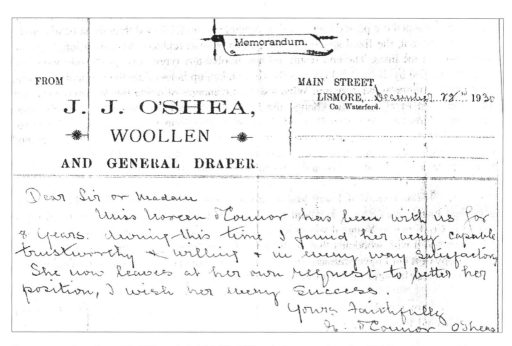

Memorandum.

FROM

J. J. O'SHEA,

WOOLLEN

AND GENERAL DRAPER.

MAIN STREET,
LISMORE, 7.8 1930
Co. Waterford.

Dear Sir or Madam
 Miss Noreen O'Connor has been with us for
8 Years. during this time I found her very capable
trustworthy + willing + in every way satisfactory
She now leaves at her own request to better her
position, I wish her every success.
 Yours faithfully
 ?. O'Connor O'Shea

A memorandum from J.J. O'Shea dated 1930. O'Shea's drapery closed *c.* 1932 and reopened in 1934 with Bobby Allison as proprietor. Tim Hegarty then ran it as a drapery and after it became a bookshop and art shop. If the cliché 'location, location, location' were true, this premises would never change hands.

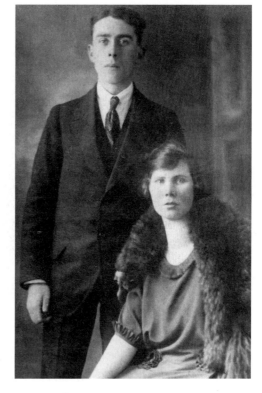

Wedding photo of Paddy (Lou) O'Farrell of Ballyanchor and Bridget Purcell of the Mill, Ballinwillin, who were married on 24 April 1923 by Canon Furlong in Lismore. We feel Bridget's stole literally stole the show; it certainly enhanced the elegant bride.

The Emergency is over and Ireland is secure thanks to men like Corporal Paddy O'Brien of Botany and the women like Mrs O'Brien who sustained them. The date was 5 June 1947 on Lismore bridge, Thursday half day; the same day as the Marshall Plan was inaugurated and the bacon industry, especially in Waterford (Clover, Denny), was reported to be in chaos. Emigration was at its height and to cap it all – not a sausage!

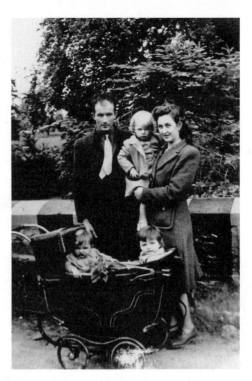

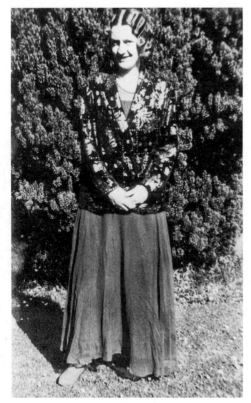

Dorothy O'Brien of Chapel Street, an altogether splendid assistant postmistress in Miss Prendergast's time. Clinically efficient and as fast as broadband, Dorothy particularly dazzled as a Morse code operator.

In the precinct of Lismore Castle gardens in the early 1920s. The man on the right was the gifted gardener Pat O'Brien, maternal grandfather of Mary Sheehan of the Villa Lismore. Pat O'Brien passed away in 1939. The man on the left isn't known but he's more likely a man who smelled roses rather than grew them!

Elizabeth Healy with Mitzy in her garden in the rear of the old post office where the Dowds once lived. Elizabeth was postmistress for many years and retired in 1929 when Miss C. Prendergast took over. One of the political Healy family (half-sister of 'Tiger' Tim), she was petite but made the five feet two inches height requirement for the job!

The homeward-bound fruit pickers plod their weary way from Bob Nolan's fruit farm in Ballyanchor, 31 July 1954. From left to right at back: Teresa Martin, Margo Whelan, Mary Ryan, Vera Murphy. Front: Kathleen Scanlan (Chapel Street), Teresa O'Gorman, Maudie Millward. Bob Nolan, married to Dodo O'Donnell, set up the fruit farm in 1950 and it blossomed for five years.

Wedding of Pete Gillen and Betty Nolan, 22 August 1962. Pete and Betty were married in Glendine church with Fr Denis McGrath as chief celebrant. Pictured from left: John Gillen, Pattie Kelly, Ellie Murray, Joe Kelly, Mary Walsh (Gillen), Harry Vaughan, groom and bride, Terry McGuire, Nora Scanlon, Sister Borgia, Mary Carney, Eily Mullins (organist), Kate Power and Carmel McGuire.

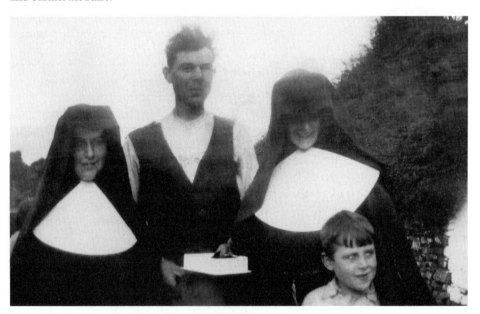

Two nuns return to their roots to reaffirm their derivation from its clay, O'Gorman's farm, Ballyin, August 1931. From left to right: Sr M. Carthage (Broderick), Michael O'Gorman, Sr Benignus (O'Gorman, later 'Mother' though the sisterhood has dropped that word) and a young Florence McCarthy. The object in the centre is a puzzle. Michael O'Gorman was a master farmer. He used to say, 'One year's weed; seven years' seeds' – another puzzle!

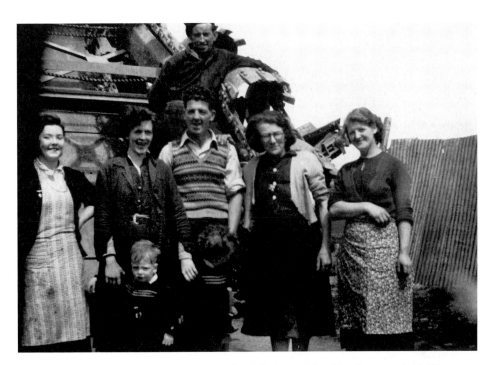

This photo recalls the water and sewage works of the late 1950s. The digger with Ned Barry aboard was parked in Botany. Front, from left to right: Maureen Feeney, Mrs Kitty Keyes, Mick Keyes, Mrs Kit Neville, Kitty Tobin. In front are two of the Keyes family holidaying from the UK.

The canal was built in the late eighteenth century. Business peaked in the 1860s, the canal trading over 10,000 tonnes in its best year, 1865. The opening of the 'Duke's Line' or railway in 1872 heralded a canal decline. The lockage book table here (The Lismore Papers) shows the volume and type of trade, 1875-1879. The merchants included P. & R. Geary, G. Acres, the Tallants of Glencairn, Matthew Crotty (father of writer Julia) and the Noonans (forbears of our artist/ cartoonist, John).

	1875	1876	1877	1878	1879
Coal	87	88.5	142	120	83
Culm	6	8	2	2	6
Corn		42	44	21	9
Flour	1.25	1.5	½		
Wheat	8.25	13.5	2	2	
Bran				13t	
Brick	5	5	11	10	24
Blocks				1	
Stone	6				
Slate		3	4	6	1
Tiles		1	½		2
Sand			1		
Gravel	3			1	1
Cement			1	2	
Salt					7
Super			7	4	5
Timber	7	39.5	56	71.5	93
Deal					2
Total Lighters	123.5	202	271	241	233
Total Tons	2,223	3,636	4,878	4,338	4,194

Monatrim, where life is full to the brim, 1948. At back, left to right: Tony McGrath, John McGrath, Mr Joe McGrath and Mrs Kathleen McGrath. Middle: Bertie Baldwin and Jim Canning. Front: Frank McGrath, Noreen Baldwin and Ann McGrath. Was the entrepreneurial Jim Canning testing out some proto shoes?!

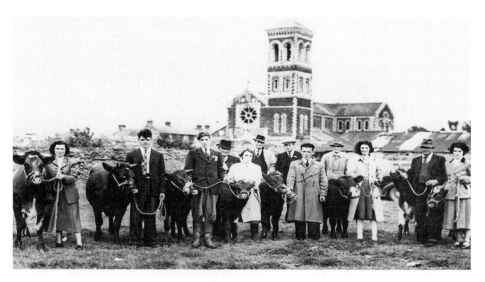

The halcyon days of Lismore Agricultural Show in the Fair Field, late 1940s. Our photo captures the irrepressible Kitty Barry, Ballinvella, brilliant cattle breeder and exhibitor of short horns in particular, winning eight prizes in cattle competitions. From left to right: Pauline O'Donnell, Lismore Hotel; Felix O'Connell, Ballinvella; Patrick Morrisey, Monatrim; Unknown; Kitty Barry; Bill Cuffe; Flo McCarthy, Ballinvella; Bill Moloney, Bishopstown; Unknown; Peg Morrissey, Monatrim; Sonny Dawson, Ballyanchor, and Noreen O'Connor, teacher at Ballinvella NS. The Fair Field is now Lios an Óir, a well-appointed estate for old Lismoreians.

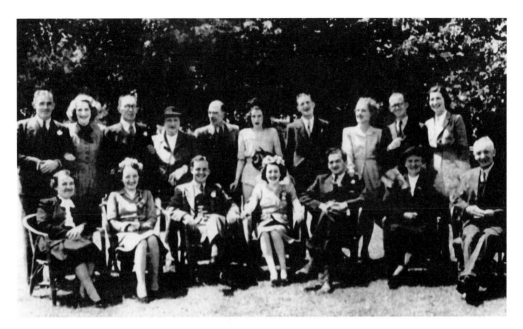

Wedding photo of Betty Hynes, daughter of Cyril and Eileen, to Jimmy McCoy at Clogheen, County Tipperary, 1947. Back row, left to right: Morty Hynes VS, Carmel Hynes, Arthur Hynes, Norrie Crowley (groom's cousin), Con Farmer (Mall Cinema), Anna Hynes (wife of Arthur), Unknown, Molly Murphy (groom's sister), Jack Lorrigan (groom's brother-in-law) and Maud McCoy. Front row: Eileen Hynes, Pat Crotty (bridesmaid), Jimmy Hynes, Betty Hynes, Tom Maguire (best man) and Mary and James McCoy (groom's parents).

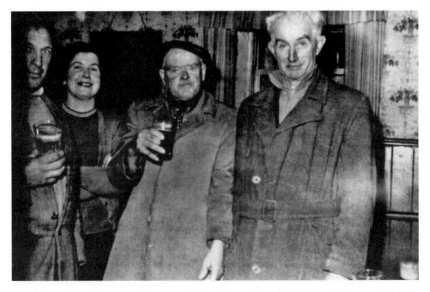

An eternal scene in a Lismore shebeen, *c.* 1954. From left to right: Dave Moloney, Biddy Greehy (proprietor), Paddy 'The Gas' O'Donnell (Glenshask), Joe McGrath (Monatrim). Dave Moloney from Ardfinnan worked in the Bishopstown area and died tragically in the Bride. Greehy's pub starred as 'Keogh's' in the film *One of Ourselves*. Paddy 'The Gas', a returned yank, led a rollicking lifestyle. Boisterous, humorous, untamed and generous in turn, he truly gave life a squeeze.

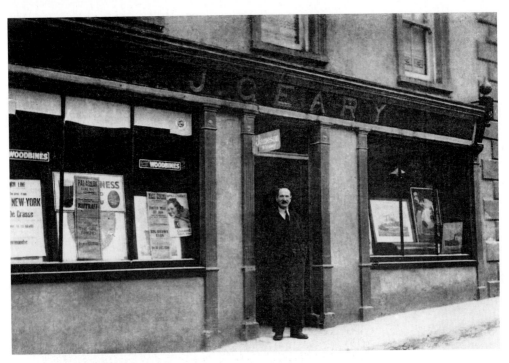

Joe Geary, publican, draper and shipping agent at his shop in Ferry Lane in the 1940s. Many migrants to America got their tickets here. Joe O'Donnell and son M.J. later ran the business as a pub and a hardware store for about fifty years. It closed in 2004 and became a video shop. A case of, as M.J. said, 'Geari, Joei, Vidi!'

This photo features three of the Paxman family at their home, Ballyrafter House in 1935. On the left is Willie and on the right Arthur Paxman and his wife. The Paxmans came from Oxfordshire. Arthur was a butter buyer and he set up the Lismore Creamery and Butter Factory at the canal warehousing site. Arthur died in 1950.

Above Right: An old horse threshing at Feeney's of Reanacoole, Ballysaggart, 1912. Threshings were exciting occasions with an element of danger: Andy Crotty's (Shrough) grandmother was killed in a bizarre threshing accident.

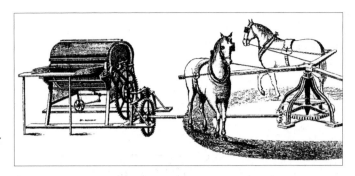

Below Right: A very rare photograph of a horse threshing at Feeney's of Reenacoolagh, 1912. Early threshing was done manually or by water power.

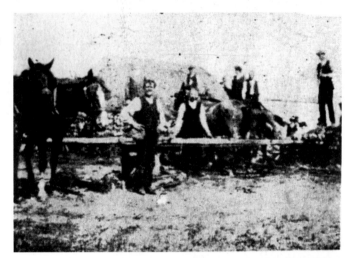

Ned Nugent and his wife Sally converted Myse Meade's old pub at the corner of Ferry Lane and Main Street into an exquisite drapery in the 1930s. The service too was exquisite even if one regrets not buying more blankets at the price!

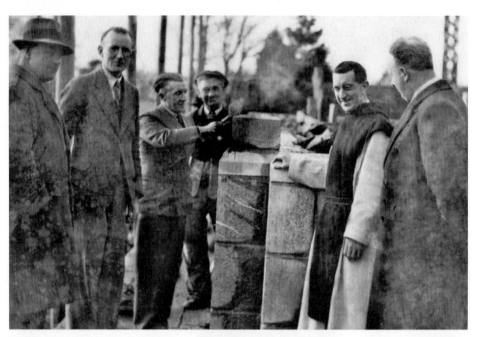

A Melleray snap of the laying of the foundation stone for St Philomena's chapel in the 1930s. Fr Robert (we think) gives the venture his blessing while reps of Maguire & Short, builders, and Jones & Kelly, architects, look on approvingly. Our real focus is on the man in the cap at the back, John 'Nutty' Keating. He was an artist with a chisel, if a bit contrary. To paraphrase Nutty, 'Our life was lonely, fixing tablets or cutting or laying stones in graveyards or chapels keeping time with our mallets to the "Dies Irae" or crows, all for a few pints yerra ... as for our own epitaph look around ye, bhoy!'

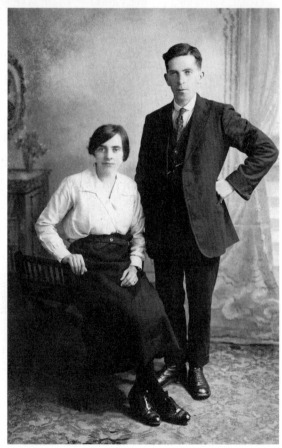

Mr Jackie Scanlan and his wife Mary photographed at the Excelsior Studios in Cork in the 1920s. Mary was from Six-Mile-Bridge in County Clare and Jackie was an early local entrepreneur who ran a news agency, the Happydrome and a sawmill.

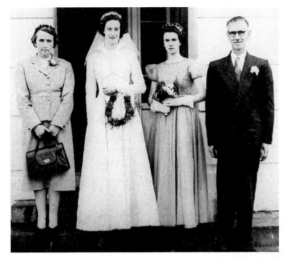

The Glasse family at Sadie's wedding day in 1958, when she became Mrs Hourigan. From left to right: Mrs Catherine Glasse, Mrs Sadie Hourigan, Elaine Glasse and Jimmy Glasse. Jimmy Glasse, from Cappoquin, set up his electrical business in the mid-1930s. Mrs Glasse later ran a souvenir shop on the premises till her demise. Jimmy Glasse was a hugely charismatic figure and his skill as a jinking, mercurial footballer was well recognised in Cappoquin and Lismore.

Wedding photo of Patrick Tobin of Monafeadee and Mary Power of Modeligo in February 1911 in St Mary's church in Cappoquin. It is said that if you want to get ahead get a hat and if you want to get to heaven get a higher hat. Mary of Modeligo surely had heaven on her mind!

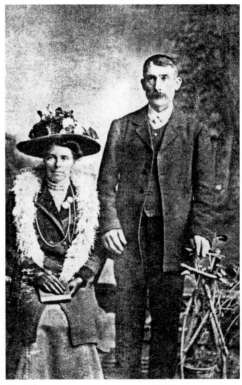

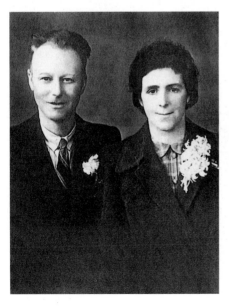

'Foxy' Mick O'Gorman and Norah Moore, of Glenshask and Monatarive respectively, on their Wedding Day in 1942. Foxy Mick was irrepressible and humorous in temperament. Hard boned and angular, he'd work the socks off townies who couldn't, according to Mick, 'pull the skin off cold custard'.

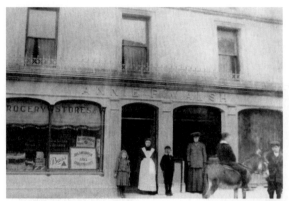

One of the most iconic shop-fronts of the nineteenth century, Annie P. Walsh's, later Madden's Summer House. In the photo we see from left to right: Kathleen Madden (Mrs Jack O'Gorman), an unnamed shop assistant, Owen W. Madden, the stately *majordomo* Annie P. John Madden is thought to be the one on the donkey, and a brother of Dickie and Lucy Walsh (of 'Lucy's rock' fame) is holding the donkey.

The shopkeepers – or perhaps 'shop-front keepers' – of Lismore deserve credit for retaining these treasures, as do the creators like the O'Briens (the wrought-iron window guards at Foley's on the Mall), Bransfields (shop front design/ painting), Keatings (maintenance of various shop-fronts), Dick Willoughby (McGrath's butcher shop relief work), Jack Nugent (maintenance), etc. Madden's venerable old business was the first in the town to win a national shop-front award (2001). The plaque high up on the left refers to Fred Astaire's visits to the old pub.

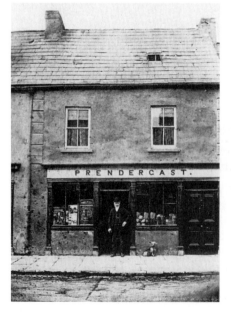

Shop-front-proud grocer John Prendergast, *c.* 1918, in the fashionable hard hat and watch chain of the era. His business, also a bakery, later became Harold Cooke's shop and then the home of the O'Neills and is now Daly's.

The Whelans of Mayfield in Youghal, early 1930s. From left to right, back row: Lassie (Mrs O'Regan), Enda (Mrs O'Sullivan) and Mr John Whelan. Front row: Maureen, who married in the US and Michael 'Jamebows'. Enda and wee Michael reflect an ineffable sunniness rare in photos of the time.

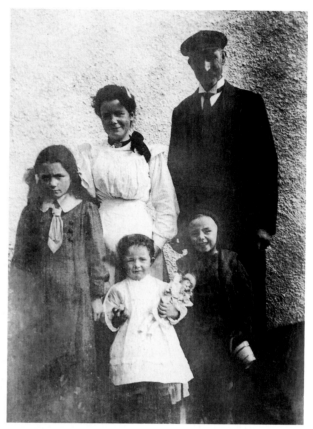

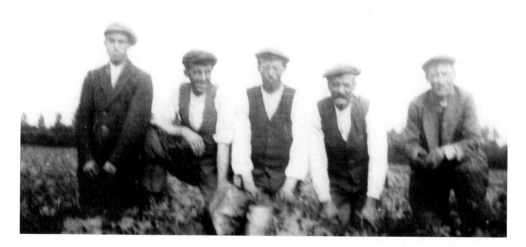

A rare photograph of men thining root crop, *c.* 1910, at Barry's of Ballydecane, Lismore> Beet was grown in Ireland since the 1840s. Of the thinning task, Jim Coady of Shrough is reported to haev said, 'any job where your backside is higher than your head is no job!'

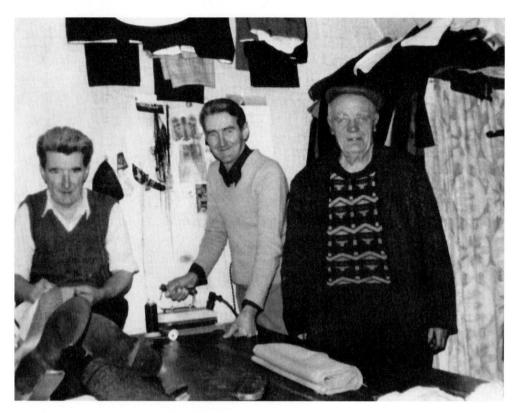

The Lismore-Cappoquin couturier connection, 1960s. The two Cappoquin tailoring Lonergan brothers, Thomas (left) and Noel. To the right is Tommie Hannigan from Killnacarriga. The Lonnergans are demonstrating the idea of the assembly line, Tommie being the customer of their proud labours.

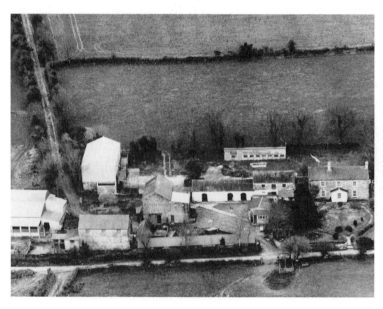

An aerial view of Brian Pearce's farm in Monatrim, 1970s. The view exhibits a fine rationality in layout and a manicuring in detail that suggests sweat and tears. Brian was a leading West Waterford farmer and founding member of the old NFA (National Famers' Association).

3

TRANSPORT, TRAVEL AND MIGRATION

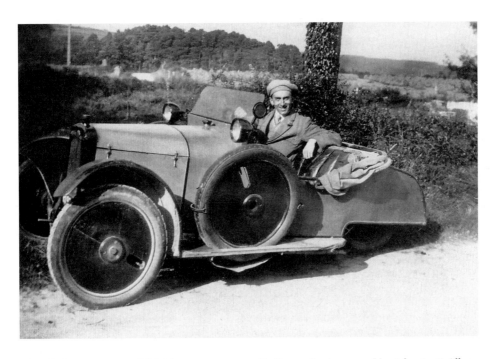

Chapel Place, Lismore, 1929. The car was an exotic three-wheeler owned by John Scott Allen. 'Leaving Lismore'

This is the place I am taking away
With me, the place of childhood dreams,
Of happiness and pain and early indiscretions,
Of slow trains shunting.

I will take this capsule with me,
To the utmost fields of the earth,
Through solar winds if need be.
It is my identity as sure as DNA.

I take with me the hills I walked,
The rivers I fished, the streets I wore out shoes on,
The initials I carved on trees, my wounds of rejection
And the failed heroes of the sporting field.

Tonight I will sand my head disconsolately
On pillows of my forebears
And in the morning awake reborn
In the lap of Sliabh na mBan,

A new template for one coined by the
Blackwater and heathered Knockmealdown.
Will it school me to shed my
Clumsy brogues of adolescence!

James Ballantyne

A recent survey by the BBC entitled *The Triumph of Technology* found that the bicycle was overwhelmingly the most significant technological development since 1800 (the bike scored 60 per cent; the internet 4 per cent). Lismoreians should feel vindicated, as the first bicycle in Ireland was made in Lismore in 1866 by a whitesmith. Folklore has it that Miss Elizabeth Lowe SRN was the first lady cyclist in Lismore prior to the turn of the twentieth century. We feature early bikes but also the humble horse and cart, plus its sophisticated applications, as in the case of Miss Clodagh Anson.

The canal was a major transport system throughout the nineteenth century and made Lismore a virtual inland port, with the odd lighter still plying it well into the twentieth century. The Fermoy and Lismore Railway – The Duke's Line – was opened in 1872 and the Waterford–Dungarvan & Lismore Railway (WD & LD) in 1878. The line was a central hub of trade and transport for nearly a century. The lovely Lismore Station was closed in March 1967, victim of clouded thinking in our national transport policy. This was not only the end of an era, but the making of a tragedy and regret in Lismore which 'down the line' has never been assuaged.

Sadly, 'The Rosslare' train, which was driven by the great Woolwich Mogul engines, steamed away scores of Lismore's 'golden lads and lassies' in the 1940s-1960s. CIE (Carriers of Ireland's Emasculated) were glad to oblige with its most dependable engines. Strictly speaking, most of those who left our shores were exiles, that is, they were forced to go. However, the emigrant/migrant may be simply seeking different or better options; he or she may not have to go and having gone may return. Our photo selection hopes to reflect this.

The Hickeys homeward bound, *c.* 1950. From left to right: Patsy Hickey, Anne Hickey and Mrs

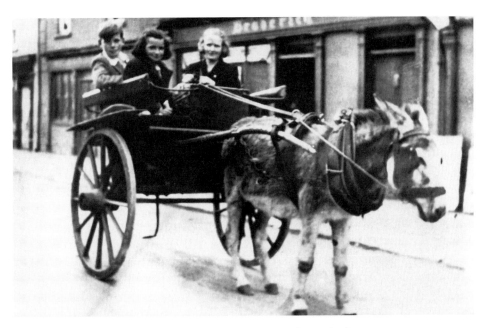

Hickey. If shopping in hard times was prose, going home in this Hickey's gig was pure poetry.

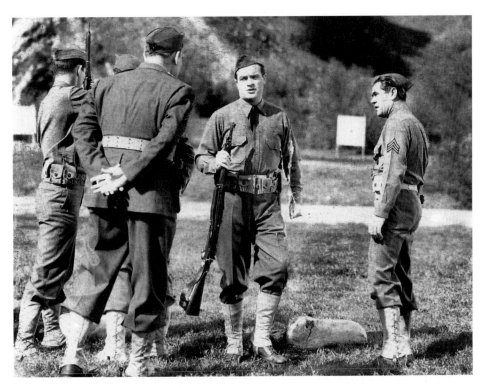

Mike Behegan, right, formerly of Botany, in the making of war propaganda movie *Caught in the Draft* in the US in 1941. The vacuous figure facing the camera is Robert Hope; the rest unknown.

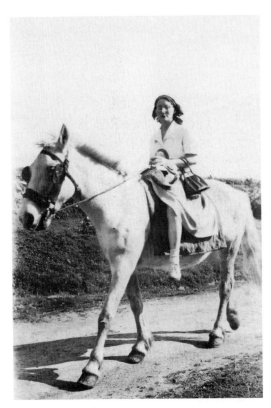

Eileen Begley from Cooldelane, home from the US in 1934 aboard 'Silver', on her way to Lismore to shop till she'd drop. Forget your home deliveries and on-line shopping, here is shopping on-horse, 1930s style.

Dashing young Lismore CBS teacher Eddie Begley of Cooldelane on his Norton, 1929. Eddie was tragically killed in collision with an unlit conveyance near Colligan in 1930. His fiancée Josie Landers, who taught in Tourin, escaped serious injury. Eddie was brother to Eileen; their youngest sibling John Joe still lives in Dublin.

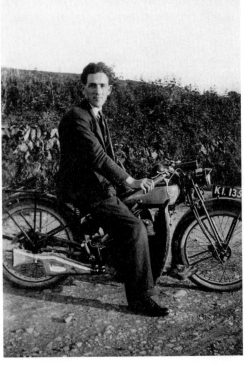

A bonny wee Ronnie O'Donnell sitting on the family Model T in his backyard, *c.* 1934. The Model T was brought onto the market in 1908; in 1913 it became the first car to be produced by the moving assembly-line system of manufacture. Wee Ron reflects how sweet it was to be young in 1934 in Lismore.

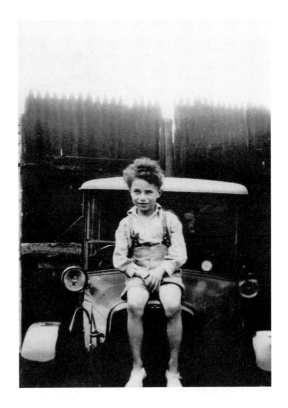

Johnny O'Gorman NT stands beside his own car as some unknown man tries it for size. Johnny taught in Melleray and Affane and was a luminary in the INTO and GAA, though not always shining in the latter. Behind we see the ivied stone house, now McNamara's, the Garda Barracks, the Munster and Leinster Bank and Murphy's Drapery.

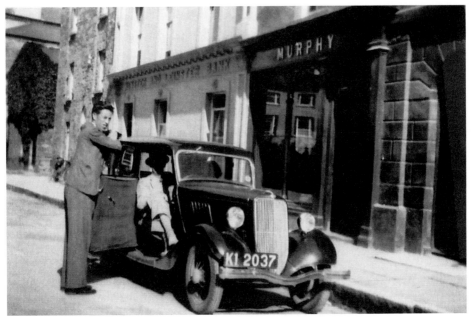

The Shrough Express, 1950s. The brainchild of Mick O'Donovan, a Shrough smallholder, this plucky initiative anticipated a rural transport scheme and off-farm enterprises that made smallholdings sustainable. Among those in the photo are Mick O'Donovan, Jerry and Mrs O'Brien and others.

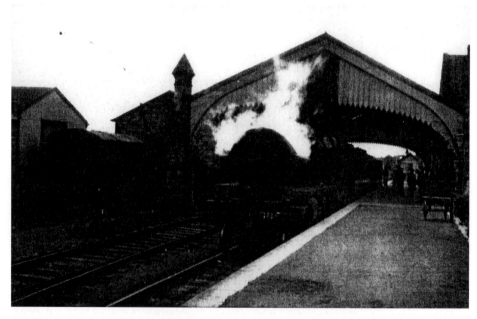

The halcyon railway days when steam was still the queen. Heustion Station, Dublin, is allowed to boast that it had the same designer, Sanction Wood, as Lismore.

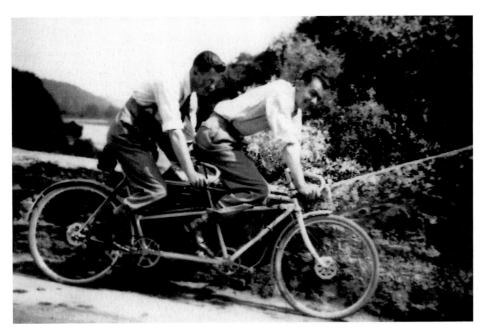

A tandem on the bridge below the town, late 1930s. The 'pilot' is grocer John Moore and the 'tail gunner' is Charlie Guest, chemist and brilliant cyclist. Tandems gained a little popularity between the wars and were often home made. An endearing and transporting image.

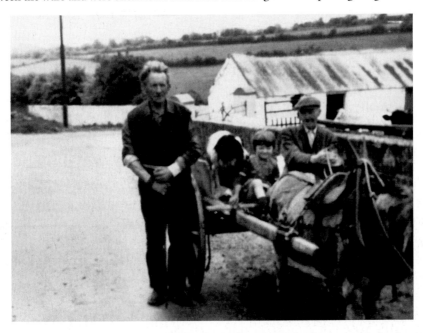

Driving by in Glen Shask in the early 1970s. From left to right: Mick Lyons, Jack the dog, Michelle O'Gorman and Mick O'Gorman. Mick Lyons deserved the honorary title 'Character' – a hardy, home-spinning philosopher with a fine tenor voice. He could notify his sister Nora with a stentorian bellow across the glen that he was due home for a meal. A saying of his was, 'Keep your heart up though your backside be trailin' the mud!'

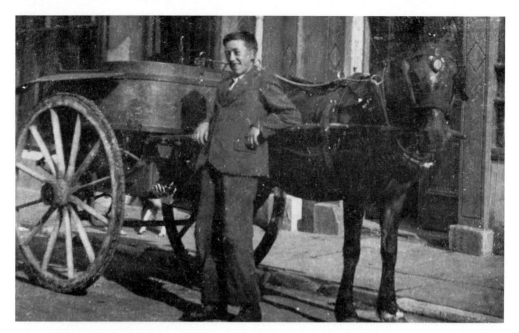

This young jarvey, awaiting a fare in front of O'Donnell's (now Mari Mina's) in late 1949, is Tommy Cahill. His fare was Frank O'Donnell, who liked to be chauffeur driven. Frank was a kind man and Tom was well rewarded.

This venerable old banger was once owned by Col. Brady and son Jim of Rath House, Shrough, 1930s. It is a Sunbeam Talbot and is currently being restored. Maurice Power is at the wheel. Miss Jacob took over Rath House after Col. Brady's time.

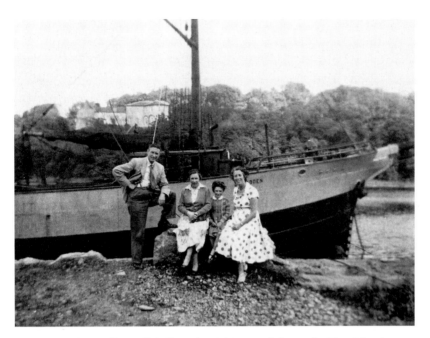

A quayside photocall at Killahalla, July 1956. From left to right: Tom Murphy, Mrs Sally Nugent, Roisin Murphy and Mrs Colette Murphy. The boat is the *De Wadden*, which plied between this quay and Wales. It later 'starred' in the TV series *The Onedin Line* and is now a maritime museum in Liverpool. Across the river we see imposing Dromana House.

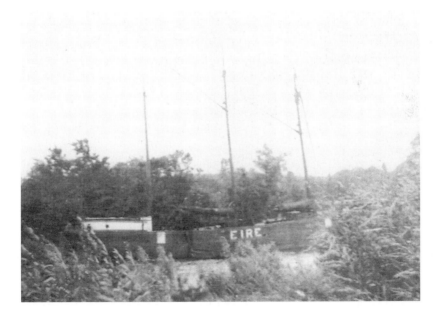

A unique image of the M.E. *Johnson* at Bishoptown Quay, Lismore, 1943. This was a three-,asted schooner, most likely discharging coal. It is the only cargo boar ever photographed on the Bride. The 'Éire' signage was a war-time peace measure.

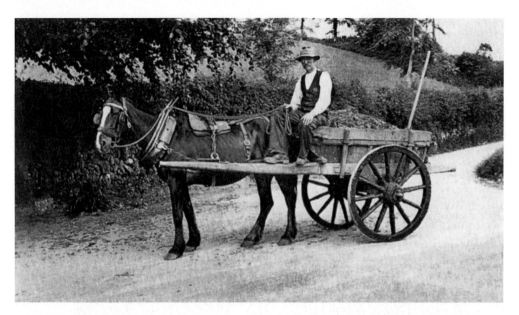

Jack O'Sullivan of Chapel Street setting out to right our roads as a County Council operative, *c.* 1930s. Many men like Jack, having acquired their own horses and butts, became independent contractors to the Council. In an era of woeful unemployment, these men were minor aristocrats and extremely proud.

Modern rural transport wear your wheels out! Here the Crottys – Margaret, left, and her mum, Mrs Crotty of Shrough – set out for Lismore, *c.* 1950, in the Rolls Royce of its day.

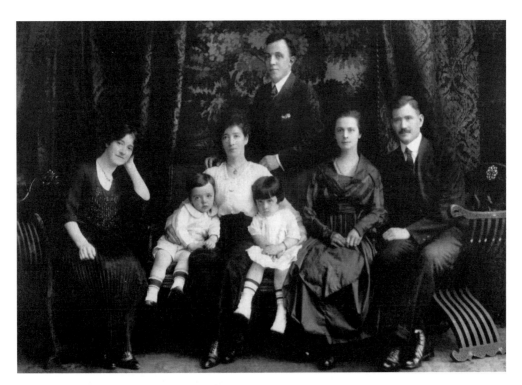

Members of Elsie Doocey's (*née* O'Brien, Deer park) family, who migrated to the US in the early twentieth century. At the back is Carthage Murray (uncle of Elsie). From left to right, seated: Ann Kennedy (aunt of Elsie), Emily Murray (aunt of Elsie) with her children Robert and Kathleen, Molly O'Brien (aunt of Elsie) and Michael O'Brien (uncle of Elsie). Missing from the photo is Denis O'Brien who died of appendicitis at twenty-seven and Joe O'Brien who lives in Boston. Elsie's parents stayed in Lismore.

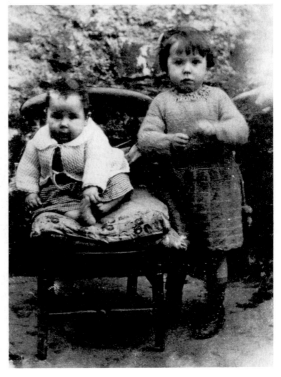

Wee Jimmy and Nellie Stapleton from Upper Chapel Street in 1924. The Stapletons lived next door (one up) to Jack O'Donoghue's old home in Chapel Street, later occupied by Paddy O'Sullivan. The Stapleton family 'up and left' for Coventry *c.* 1934 after the closure of Paxman's, where Mr Stapleton worked.

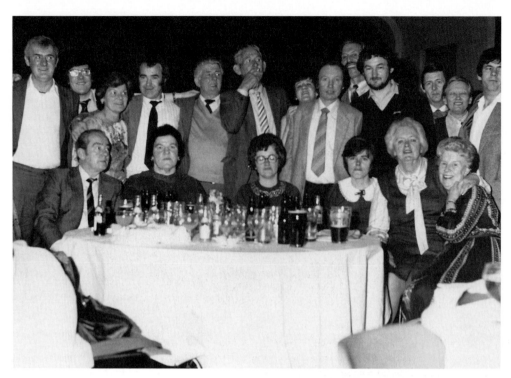

A Lismore and Tallow soiree in London
c. 1962. From left to right standing: Tom
Pratt, Denis Pratt, Breda Pratt, Phil Flynn,
Mick Keyes, Gordon Whelan, Unknown,
Mick Gillen, Jack Whelan, Unknown, Patsie
Bray, Unknown and Pat Healy. Front: John
'Panzer' Behegan, Peggy Flynn (*née* Begehan),
Unknown, Unknown, Mrs Mick Keyes and
Bebie Behegan. John Behegan summed up a
great night: a night to remember followed by a
day to forget!

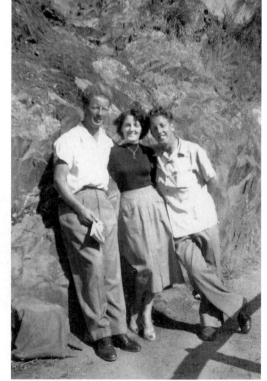

Radiant in the foothills outside Adelaide in
1950, Ned, Bridie and Gordon Keyes, formerly
of Botany. The Keyes family practised an astute
'stepped migration', that is, to first go to the
UK and absorb the migrant experience, then
step further abroad, like to Australia. Of the
great Keyes family only Gordon now survives,
but the bloodline is secure on two continents.

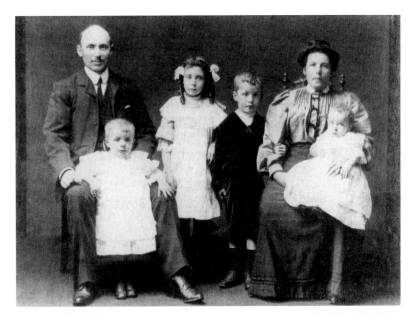

In *Images of Lismore* (2005) we featured Judge Al Burns (p.115) to represent Lismore's genetic footprint in the USA. This photo highlights the same in Australia. It was taken in Scotland in 1904 prior to Jeremiah Ormonde (brother of John, who set up Ormonde's business in 1898) going to Australia with his wife Bridget (*née* Riley) and family. The children are, from left: John, May, Jim and baby Tom. John died in childhood, May became a nun, Jim became an Australian Senator and died in 1970 and Tom was a scientist. There were three other children: Billy, Peter and Frances (Kit). The Ormonde line continues in Australia.

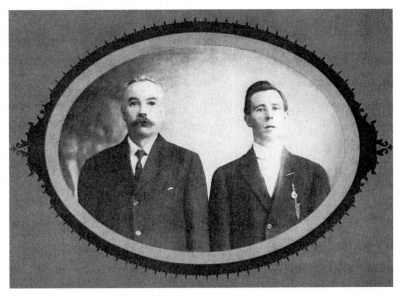

A century-old photo of Pat and John Coleman. John (right) was father of Andy and Fr Mikey Coleman. Pat was John's uncle. Pat emigrated to New York in 1889 from Carrignagour and John in 1907. John came home in mid-1920s and opened a general store on Main Street (now McCarthy's Insurance).

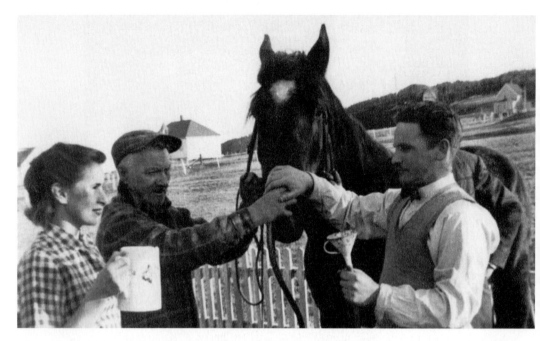

John Hobson VS, Lismore's second vet, emigrated to Canada in the early 1950s. Here we see him on the right dosing a horse in Cape Breton in 1955. John was Cape Breton's very first veterinary surgeon. Well known in Lismore in the 1940s, along with Cyril Hynes VS, John once treated a circus lion called Sultan. The lion recovered. John is still alive and well and fondly recalls his farm visits around Lismore on his trusty motorbike.

4

WAR AND PEACE

Memorial to the 'greatest Church Lane man', Thomas Greehy, in Ballyclement Wood, Kilwatermoy.
Thomas, a battalion quartermaster in the War of Independence, was brutally murdered in the Civil
War by dissolute Fermoy Free-Staters. Known as a dauntless Volunteer who fought for 'the secret
scripture of the poor', he is buried in St Carthage's Cemetery.

'The Mall of Lismore' (song)

Once that I courted a soldier,
And he was the first won my heart,
We got married and annonced to our parents
And we vowed that we never would part.
But now all his vows they are broken.
Alas! I can see him no more.
He is gone and he has left me alone,
Oh alone at the Mall of Lismore.

In Dublin his regiment was called in,
To go my young soldier should tramp
And for to dispute with the Sergeant,
My bonny young soldier was wronged.
He was tied up to a hard pole,
With lashes, his skin it was tore,
And that was the cause of he leaving me
Oh alone at the Mall of Lismore.

Anon

The very earliest name of Lismore, namely Dúnsginne or Magh na Sciath (Manaskea) had military connotations. As outlined in our Introduction, Lismore was regularly 'in the wars'. Our Lismore song above combines the lethal mixture of love and war.

Lismoreians served in many arenas of war. A Charles Quirke fought in the American Civil War and John Duggan with the Americans in the Second World War. An intrepid Lismoreian is said to have accompanied Vasco Da Gama on his voyages of discovery. The most noble fight of all was fought by those who actively engaged in our War of Independence. We remember and honour these unreservedly. Lismore had its representative group who fought for Britain in different arenas. Many of these were seeking adventure and some saw a posting as a job as against no job.

The position of Ireland in the Empire may have resulted in a condition we may call 'imperialist schizophrenia'. Conscription into the First World War best illustrates this, as men were induced to fight for the freedom of small nations by a misguided imperialism which denied freedom in their own. Lismore parish perfectly illustrates the schizophrenia in the case of J.H. Lovett, imperialist, and Thomas Greehy, separatist. These men were two of Lismore's finest, the former taking for granted the vaunted virtues of Empire, the latter its demonstrable evils. Both died violent deaths, which demonstrates that war may be just but its consequences are always evil, especially for individuals.

The Garda Siochána represents the perduring symbol of law and order. This force replaced the RIC in 1922. Initially, an armed force was envisaged but a limited mutiny by the IRA in relation to offering RIC personnel important posts led to a happy outcome, that is, a philosophy of moral authority was defined for policing in Ireland. We feature the remarkable Chris Houlihan, who was an active freedom fighter who joined the new Garda force in 1922 and served over fifty years, mostly in Lismore.

The so-called Emergency saw our defence forces come into their own; men such as Corporal Paddy O'Brien, Private Moses Kennedy and Sergeant-Major Horace Dowd. Also, personnel of the local Defence Force which became the FCA or Fórsa Cosanta Áitiúil in 1947.

A political protest outside Goulding's in early 1900. Goulding's, a kind of revolutionary safe house, was on occasions under siege from Crown forces. Seán Goulding, later Chairman of the Seanad, changed Goulding's to Ua Guilidhe. Parnell spoke from the bay window in Ferry Lane and Dev visited the premises. Sean Goulding was a leading Volunteer with the West Waterford Brigade and overall he deserves more concrete local remembrance.

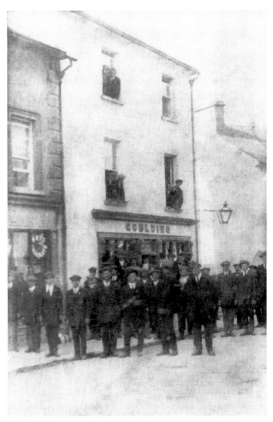

This certificate testifies that Patrick Hickey (aka 'Malach Regan') joined the Irish Volunteers in April 1917 and took part in the War of Independence, 1916-1923, in the Déise Brigade. Note that Lismoreians Tim Duggan and Paddy Morrissey also signed the cert as Volunteer leaders.

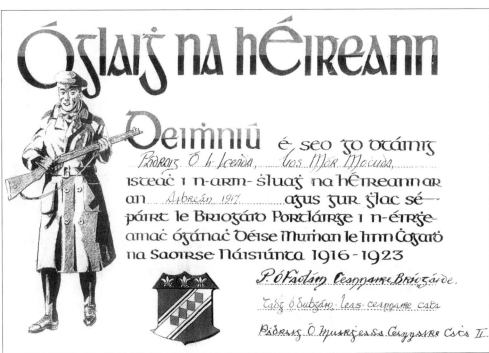

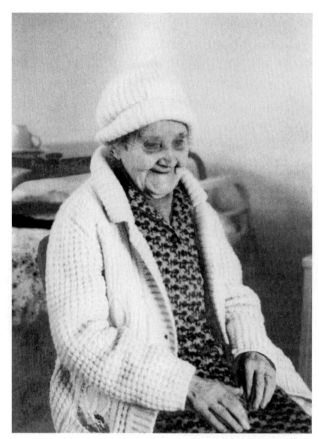

A sterling lady, Lizzie Collins, in St George's Home, *c*. 1992, where she spent her final days. Lizzie, wife of Moss who gardened at Lismore CBS, was an active member of Cumann na mBan, rode a motorcycle and carried despatches. In an age of tawdry and empty celebrity, try the likes of Lizzie as an alternative!

This fine portrait of Joe Collins of Botany was completed in homage to Joe by his artist grandnephew Gez Taylor *c*. 1975. Joe was a principal in the burning of the Court House in 1920 by IRA Volunteers in the War of Independence. Flames almost engulfed Joe as he descended the ladder and then, ducking bullets, he fled in a shoot out. Joe's brother Moss was also a Volunteer and later a CBS gardener. Joe died in London in 1983. He was a true local hero, Joe, winner of the greatest conceivable prize – freedom.

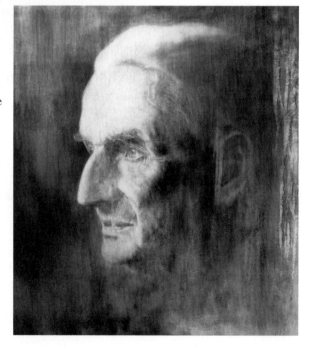

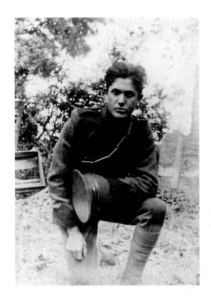

Joe Ballantyne in Keash, County Sligo, *c.* 1917-1919. Joseph had a very creditable War of Independence and was a secret agent in Liverpool. He was Garda Sergeant in Lismore (1937-1954). An extremely efficient and genial policeman, his motto might well have been, 'the better part of policing is discretion'.

Joe O'Connor of Chapel Place in British naval uniform, 1918. Joe was a signal man with mastery of semaphore and Morse code. He fought on battleship HMS *Bellerophon* and fought at the Battle of Jutland. Joe settled in the UK after the war, marrying Olive Hatch.

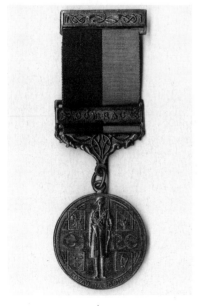

An image of an active service Volunteer medal from the War of Independence. It was bestowed upon Lismore Garda Chris Houlihan for service during the 1917-1921 period. It is surely the gold standard for Irish participants in war or combat anywhere and for whatever reason.

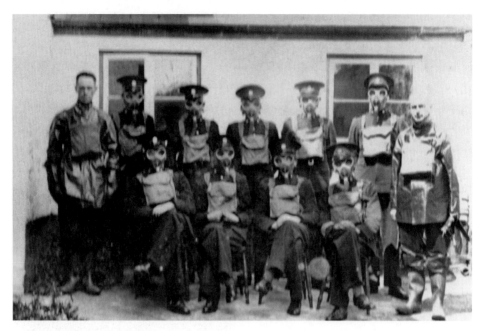

Gardaí masked.

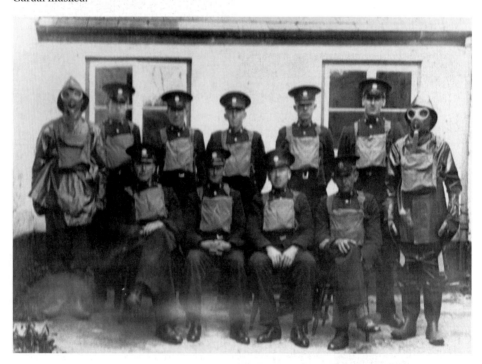

Gardaí unmasked. These 'before and after' photos show Lismore Gardaí, with others, during the Emergency. No one can answer the question of who will guard the guards, but it is clear here who will instruct them: the Local Defence Force demonstrators to left and right. The three Gardaí we can name are sitting in front. From left to right: Garda Chris Houlihan, Garda Jim Byrne and on the extreme right, Sergeant Joseph Ballantyne.

Private Pa Fives Ballinvella in 1914, when he joined the British Army. His dream of adventure, even a career, ended in 1916 when he was killed in combat. Small blame to a man with limited career opportunities to be lured by the romance of war but how sad the outcome. We honour Pa by remembering him.

Royal Irish Fusilier John Clancy from Ballyin in the Second World War. John fought at the Battle of the Somme, survived the terrible slaughter and was awarded a 1914-1918 service medal. He married and raised a fine family in Ballyin.

Mine sweeping with Chris 'Purse Net' O'Brien in the Second World War. Son of 'Mick the Bird', Chris got his nickname from his hurling days. Here, Chris (left) is on board a mine sweeper in 1944 in Malta with a pal.

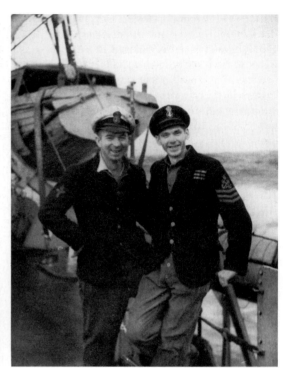

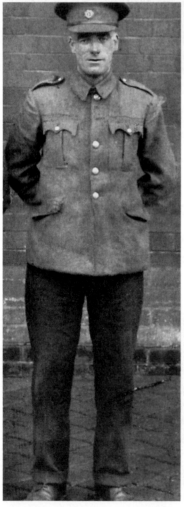

Private 'Moss' Kennedy. A Kilkenny Cat (Piltown), he loved gadgetry and was a fantasist. Billy O'Riordan, renowned scientist and Freeman of London credited Moses with first arousing his scientific interest. Moses passed away in 1976 and is buried locally with his wife in, sadly, an as yet unknown grave.

A soldier of destiny handsomely rigged in riding breeches, Sam Browne and gun at ready – Edward Coughlan of Church Lane. He was a fine barber with a business in East Main Street (where Keith Dowd now lives). All of Edward and Cathy Coughlan's children went to the UK bar Bridie. Jimmy, the only boy, married into a well-known footy family in Worcester, which was like marrying into the gentry in Ireland. However, Jim didn't like football, saying it was the most boring game in the world next to cricket.

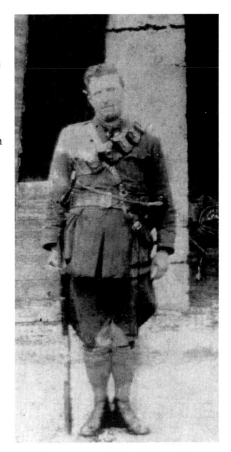

Garda Houlihan on his motorbike in the 1940s. On the extreme left is Garda Paddy Martin. The bike was not Garda issue but rather Chris's own. The others in the photo aren't known, though the pillion passenger could be Michael Houlihan, Chris's son.

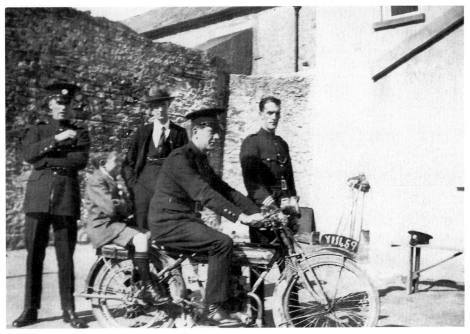

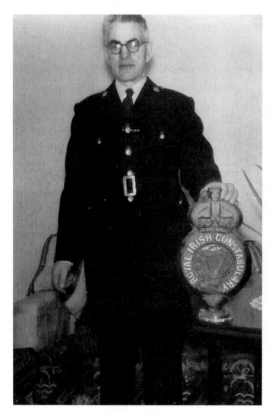

Garda Michael Mason holding the old RIC emblem that hung at Lismore barracks up till the Gardaí accession. Garda Michael was making the link between the two forces, for better or worse. Lismore Garda Barracks became a first-class station, the very first operation Garda barracks in Ireland. It was situated, if only for a brief period, in Lower Chapel Street, where John McGrath now lices.

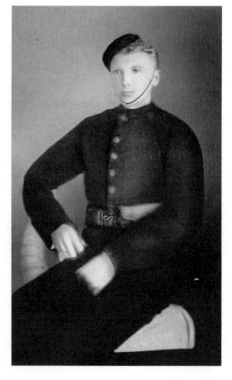

Thomas O'Connor, RIC recruit, 1876. Born in 1855 in Foynes, County Limerick, O'Connor came twice to Lismore and married locally in 1896. He lived in Chapel Place (now Lee's) but resigned from the RIC in 1906. Thomas was the maternal grandfather of Frank Mason.

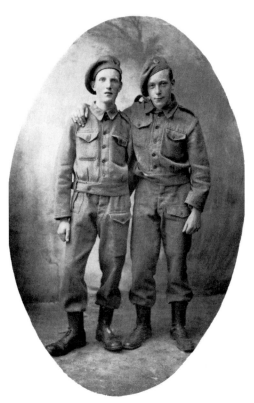

Two splendid LDF (Local Defence Force) boys of 1945 – Michael Broderick (left) of Main Street and Billy Sheehan of Church Lane. Mick went from 'Dad's Army' to 'God's Army' in Melleray Bros, Aengus. Billy later left for Bristol, married there, had three children, and died in 2004.

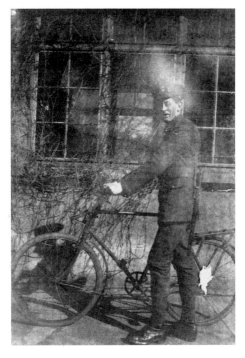

Town postman Jim O'Donnell in the 1950s. Jim joined the postal service at eleven years as a telegram boy and served fifty-seven years in total. A charismatic 'man of letters', his dog Bran used to travel out with him even to Ballysaggart. Married with two children, Seamus and Margaret, Jim died in 1962.

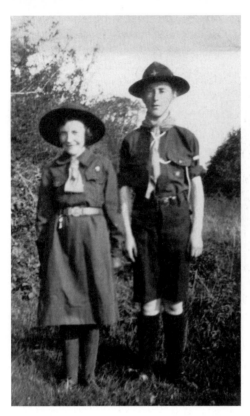

Girl guide Monica and boy scout Tom Noonan in early 1935. Fr Tom Murphy started the scouts in Lismore in 1934; a little later the girl guides were set up. Monica and Tom have now passed on but this charming photo donated by Tom will always recall two of the earliest recruits in their glorious scouting days.

Below: Uniting the Baldwins of Lismore and Boston in gravestones across the sea. On the left is the Baldwin family gravestone (next to Pa and Joan Sheehan's) in the old cemetery on Chapel Street. It required a dig to uncover. On the right is Ned Baldwin's name on the reverse side of Baldwin's gravestone in Hollyhood cemetery, Brookline, Boston. Ned, a Lismore Baldwin was the 'Irish Giant', a world-class boxer of his day who was murdered in New York. His name positioning betrays some family conflict. Thanks to retired Judge Al Burns of Boston for tracing Ned's final resting place despite sparse and misleading information.

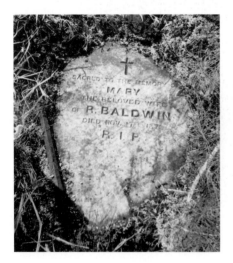

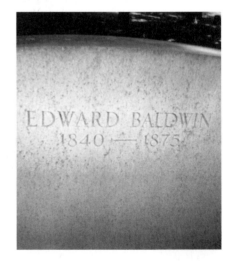

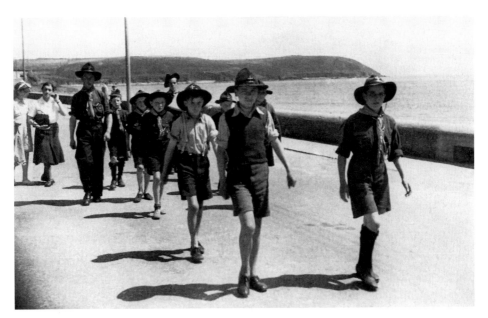

Youghal Summer Camp 1946. Front from left is Billy O'Brien and Peter O'Brien. The boy second behind Billy is Mick Scanlan, then Richard Broderick and lastly Mikey Coleman, John 'Twinner' Scanlan is at back right with hat askew while Andy Coleman leads to left. This was a disciplinary route march for culprits who disgraced the troop by being out of step, dilatory and badly attired. Andy Coleman was detailed to march the deviants till they were proficient. In using this photo we recall the brilliant and exuberant Billy 'Irons' O'Brien who died 31 January 2010.

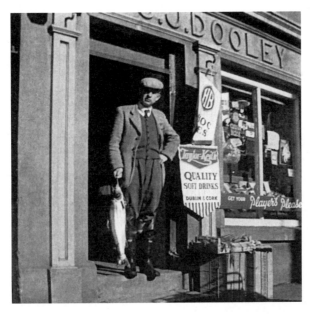

Veteran of the Second World War Joe Dooley of Chapel Street with the fruit of his hobby *c.* 1960. Joe was captured by the Japanese but avoided torture by instructing his captors in chess. The game taught Joe how to keep a move ahead.

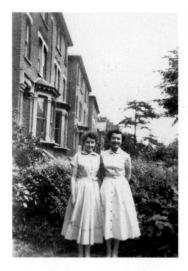

Lil (left) and Mary Power of Shrough East pictured at King Edward's Memorial Hospital, Ealing, London in 1953, where they studied nursing. Lil returned to Ireland and married into the Costin family of Affane, while Mary married Chevalier Paddy Doherty in the UK.

Eoin O'Duffy speaks at the Monument at a United Ireland Party (aka the Blue Shirts) meeting in January 1934. A distinguished freedom fighter who became Garda Commissioner, he became fascistic; Dev sacked him in 1933 and Fine Gael subsequently dumped him. Lismore's strong farmers welcomed him and Canon Burke, to his shame, leant him a spurious legitimacy by basking in his ease in his wheelchair on stage. However, the pubs did well and there was great craic.

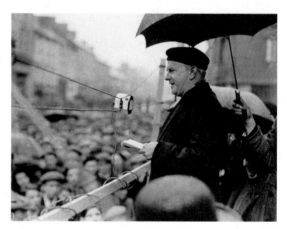

This elaborate plaque in the Church of Ireland Cathedral marks the life of J. Henry Lovett, scholar and petty imperialist born in 1780 and drowned in 1805 off the Cape of Good Hope. We number him among the 'great Lismoreians' like Thomas Greehy. We commemorate the scholarly, imperialist-serving Lovett; we celebrate the separatist Greehy. We honour both in recalling them.

5

RELIGION AND
EDUCATION

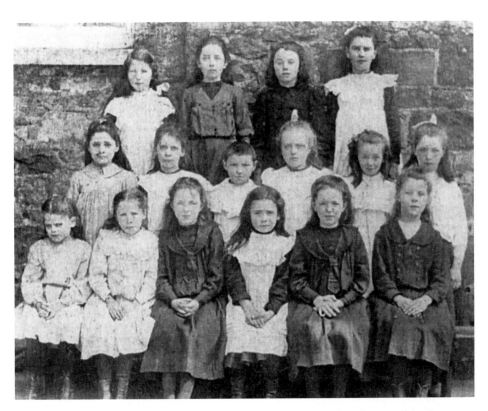

Lismore Presentation Convent primary class, c. 1914. The names of the four pupils in the
back row are unfortunately unavailable. Middle row: Mary Agnes McGrogan, Annie Pender,
Lily O'Connor, Kathleen Morrissey, Mary O'Connor and Annie Evans. Front row: Ada Wright,
Maggie Forde, Judith Aherne, Eily Byrne, Lizzie Aherne and Kit O'Gorman (Ballyfin).

'The Nuns, Come and Gone'

Quite far flung the nuns now
But their nunness comes back to me,
Diffuse I thought their infused holiness
But their holiness comes back to me.

Smooth as rolled silk I see them glide the garden
Subvocalising matins, acknowledging robins,
Beyond the Chapel, barely noticeable,
Stillness itself, their cemetery sleeps, provisionally.

Gone for good now but not good they're gone,
But Sister De Lourdes always comes back to me, and –
The Covenant Mass – that twitchy soul of up-early godliness
Will always, always, come back to me.

E.F. Dennis

Lismore has ancient fame in the dual area of religion-education. In Butler's *Lives of the Saints* we read, 'Lismore is a famous and holy city, half of which is an asylum into which no woman dares enter; but it is full of cells ... and religious men in great numbers abide there ... not only from Ireland but also from Britain.'

In the eighth century, the school of Lismore stood in a higher degree of reputation than any other Irish seminary. St Carthage himself made it a Bishop's See and it still remains thus, although it combined with Waterford in the year 1362. The twelfth century saw the prelates sacrifice Ireland's sovereignty to Henry II at Lismore, lest their own privilege be usurped. This could've attracted branding of the town as Ireland's quisling home-place, but twelfth-century public opinion invested prelates with gratuitous powers. The idea of Ireland as priest-ridden may have its origins here or its converse: that priests were people-ridden.

Charles Smith wrote of Lismore in the eighteenth century, 'A traveller, at present, would hardly take this town to have been a university, Bishop's See or much less a city. Instead of its ancient lustre, the cathedral, the castle, and a few tolerable houses, intermixed with cabins, are all that now appear.'

The Catholic Relief Act of 1793 and Catholic Emancipation of 1829 allied to the improving interventions of the Bachelor Duke in the nineteenth century turned things round. The coming of the Christian Brothers and Presentation nuns crowned a renaissance.

As noted earlier, a photo asserts to the fact that something did exist. The photos here attest to a rich heritage. We might even observe that photography arrived opportunely as a handmaiden in recording Lismore's religious–education–literary history.

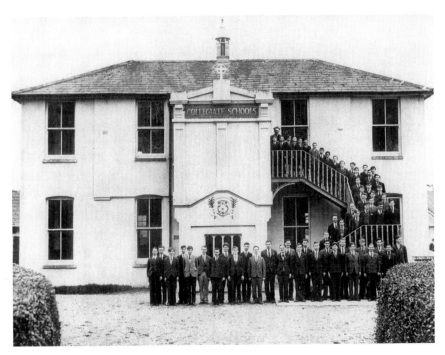

A muster of the Secondary school of Lismore CBS in the 1920s. The second person on the stairs is the eminent teacher and later GAA President Vincent O'Donoghue. The brother at the top is likely Br John Carey, Superior. The lower part of the building was the Primary section of the school. The building is now demolished.

Botany décor for Eucharistic procession, 1940s. The household is Whelans. From left to right, back row: Mickey Whelan, Mrs Whelan and Gordon Keyes. Front row: Mrs Mickey Whelan and Chris 'Snacker' Whelan.

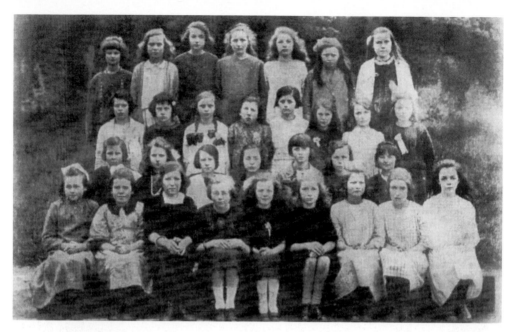

Girls' class, Presentation Convent, Lismore, 1923. From left to right, back row: L. Sutton, Alice Foley, Nell Foley, Isa (Isabelle) Rice, Alice Creagh, Mary Crowley and Bridget Feeney. Third row: Maggie Whelan, Mary B. Lineen, Mary Foley, Kathleen Byrne, Annie Callaghan, Molly Lynch, Hannah Murray and Hannah Morrissey. Second row: Kathleen Kemp, Mary Mountain, Maureen Sweeney, Aggie Healy, Brid Donnell, Eily Doherty and Julie Callaghan. Front row: Mary O'Sullivan, Mary Vaughan, Alice Walsh, Gretta Walsh, Kitty Curtain, Aggie Lawton, Eily Conlon, Maureen Fitzgerald and Anna Brien.

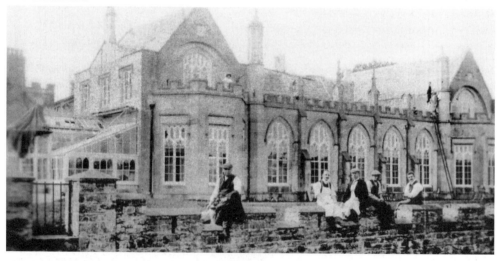

This view of Glencairn Abbey was snapped c. 1910. We can see seven workmen and a servant girl aloft the castellated cloister. St Mary's Abbey Glencairn dates from 1926, when Abbot Maurus O'Phelan of Mount Melleray bought it from Ambrose Power in order to set up a nunnery. However, it was originally part of Lismore's monastic settlement. Currently, there are just over thirty nuns of the Cistercian Order there.

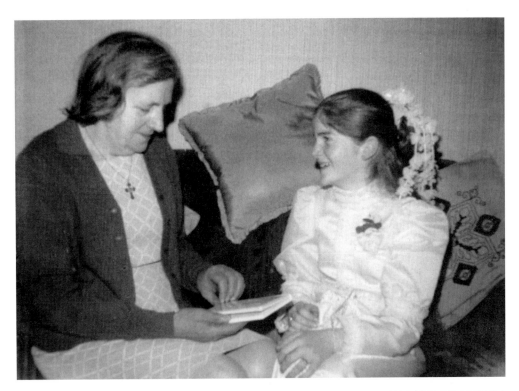

Lismore woman honoured by the Pope. Madge Walsh, formerly of Deer Park, was honoured with the award of *Bene Merente*. Madge was housekeeper to the three Archbishops/Cardinals of Armagh. A fine lady, she's buried in the churchyard of Lismore Cathedral.

The cool young Hales of Ballyin at Presentation Convent in 1926. From left to right, back row: Eily Hale (UK and latterly South Mall) and Peg (Mrs Herbert and latterly South Mall). Front row: Frank (homeplace), Mary and Josie (Mrs Roby, retired from UK to Devonshire Cottages where she's still hale and robust at ninety-two).

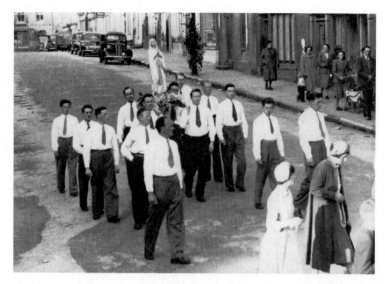

Lismore Legion of Mary members bearing the statue of BVM in the
Eucharistic procession, *c.* 1956. First row, to left from back: Ca O'Donnell,
Tony Bransfield, Michael Broderick, Liam Power and Pad Lineen.
Carrying the statue, to left from back: Pete Gillen, Billy Hogan, and two
not known. Second row, from back: Matt Gough, Pad Flynn, John Pollard,
Mick 'The Bird' O'Brien and Andy Crotty. On the right on the path alone
is Mrs Wall and in front of the Legion group are Ann Quinlan, left, and
Mrs Leo O'Donnell with rosary beads. The Legion of Mary is now defunct
in Lismore.

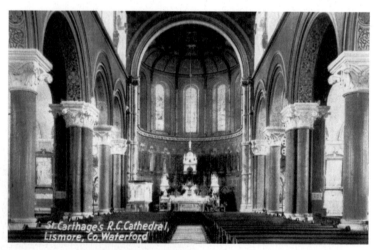

The interior of the Catholic Cathedral prior to 1954. The six stained
windows are by Cox, Buckley and Watson and are dedicated to the great
events of the lives of Jesus and Mary. The altar was Carrara marble with
onyx inlay and cost £912. After Vatican II, a table altar was installed
and the pulpit removed. The seating was by Hearne's of Waterford. Part
of the altar rails, donated by Miss Dobbin of Lismore Hotel, survive in
the side altars.

Presentation Convent, Lismore, 1946. From left to right, back row: Mary Ryan, Helen Tobin, Kathleen Hale, Anna Doyle, Fiona Boyle, Bridie Enright and Finola Healy. Front row: Dolores Nolan, Maggie Coughlan, Marjorie Meaney, Bernadette Doyle, Betty Nolan, Eileen Henley, Kathleen Heskin and Alice Power.

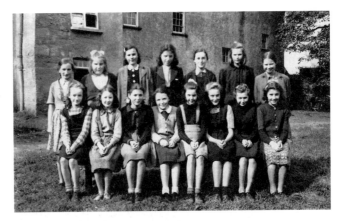

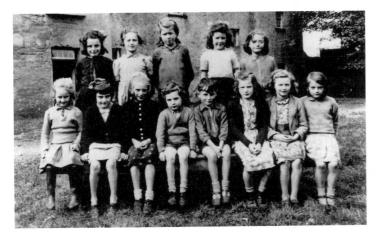

Surrounded by women. A charming school photo from Lismore Convent, 1947. From left to right, back row: Margaret Parker, Bridie Coughlan, Teresa Kennefick, Kay Tobin and Maida Cahill. Front row: Teresa Martin, Mary Ryan, Dolly Hickey, John O'Riordan, Billy O'Riordan Margaret Doocey, Angela Murphy and Martha Creane.

Lismore CBS Primary School, third class, 1945. From left to right, back row: J. Morrissey, Mick Tobin, Tom Connors, J. Connors, Mick Doocey, J. Singleton, Ned Doherty, Mick Uniacke and Pete Neville. Middle row: Mick Murphy, ? Uniacke, Tom Cahill, Seán Dennis, John Lamb, Willie Walsh and Frank Mason. Front row: Frank Frawley, Richard Broderick, Joe Martin, Des Frawley, Paddy Hickey, Willie Madden and R. Burke.

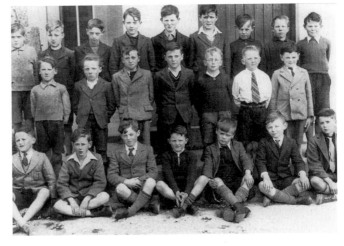

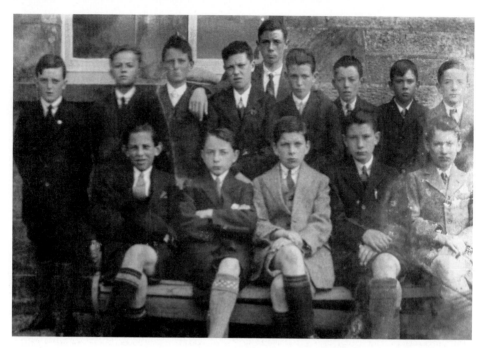

Lismore CBS class photo from the mid-1920s. The photo was recovered from a damaged original. Only two boys can at present be named: N. O'Connell, first left standing and Peadar Hickey, first right sitting.

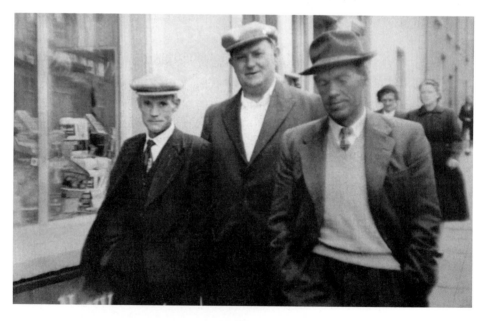

Coming from Mass in 1957 are, from left to right, Jimmy Kenneally, Bob Lineen and Patsy O'Gorman. Passing Quinlan's shop and anticipating some *après* Mass refreshment at the famed Red House, all are farming men needing respite after a week bullying the stingy earth or trying to save hay ahead of hysterical rain.

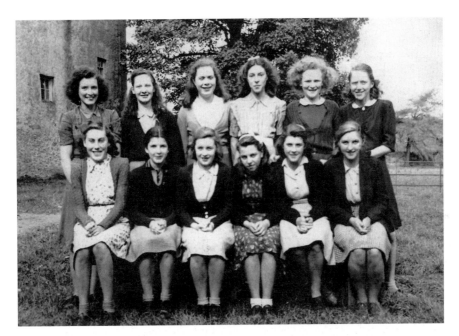

Intermediate Certificate Class, Presentation Convent, Lismore, 1947. From left to right, back row: Margaret Guinivan, Kathleen O'Donoghue, Eva Murphy, Eily Moloney (Mallow, lived with grandparents Stapleton's of Chapel Street), Nora Fives and Carmel Browne (Cappoquin). Front row: Ann Scanlan, B. Nolan (Cappoquin), Mary Gillen, Kathleen Keating, M. O'Gorman and Joan Guinivan. At the rear is Maher Memorial School, built 1925. The former site of a Protestant boarding school, it was demolished *c*. 1960. It was a favourite site for class photos, though not a pretty backdrop.

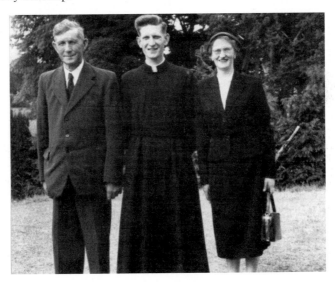

Proud parents of Richard Broderick, Main Street, after his ordination as MSC priest in 1959. Fr Richard has been a missionary in South Africa since his 'great day'. Saving souls can't be easy but it must be remembered that Richard played with fine skill and much success probably the greatest character-forming game in the world – handball.

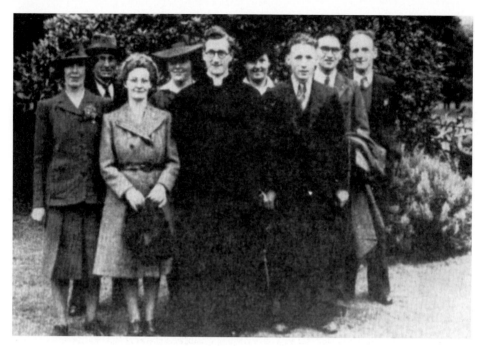

The ordination of Fr Prendergast, Monataggart, Ballysaggart, 1945. Back row, from left to right: George Armstrong NT, Josephine Hackett, Mary O'Donnell, Jim Armstrong NT and Paddy Hackett. Front row: Angela Higgins, Kitty Prendergast, Fr Patrick Prendergast and Andrew Prendergast.

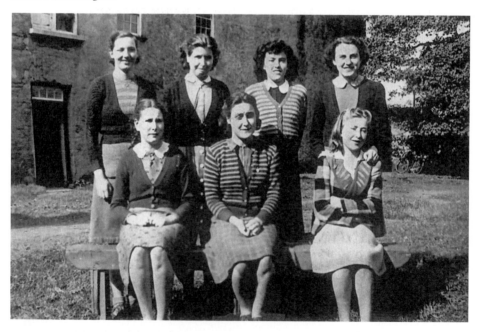

Lismore Presentation senior class in the late 1940s. Back row, left to right: Mary Fitzgerald, Bridget Greehy, Eileen Lineen and Margaret McCarthy. Front row: Mary Casey, Kitty Fitzgerald and Kitty Power.

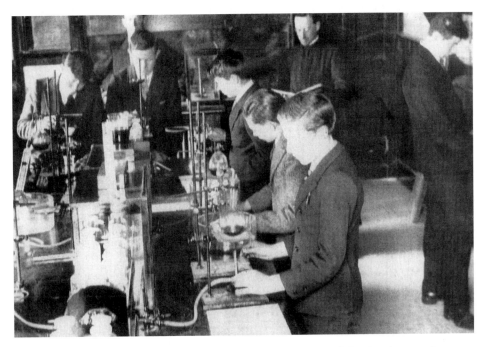

Chemistry class in CBS, 1920s. Vincent O'Donoghue supervises, while a brother may be reading the prayer against laboratory explosions! The blackboard drawings, if not a chart, is likely the work of Mr O'Donoghue, a painstaking artist with chalk.

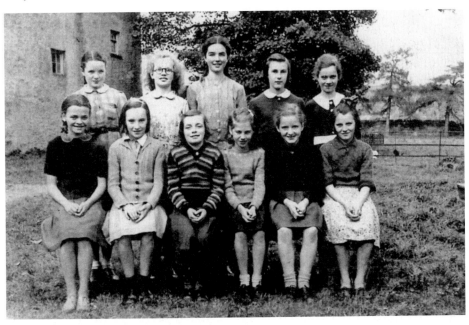

Presentation Convent Primary School, sixth class, 1947. Back row, left to right: Mary O'Farrell, Bridie Lineen, Maureen Dunne, Ann Quinlan and Rosie Murphy. Front row: Helen Keating, Eileen O'Sullivan, Margaret Hickey, Gertie Colbert, Siobhan O'Donoghue and Eileen Crowley.

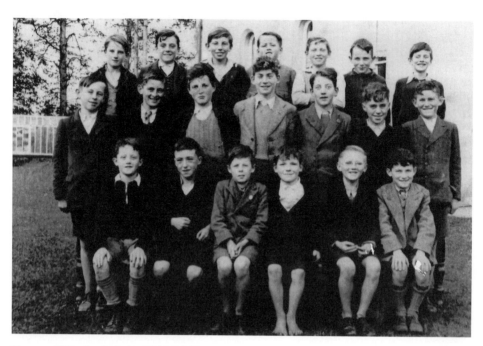

Lismore CBS school photo, 1948/1949. The students are drawn from fourth class primary school to first year secondary. From left to right, back row: Mick Murphy, Seán Dennis, Mick Scanlan, Frank Frawley, Richard Broderick, Joe Tobin and Andy Coleman (Carrignagour). Middle row: Ned Doherty, Tom O'Connor, Michael Doocey, Bertie Nugent, Tommy Maloney, Terry Forde and John 'Alfie' Whelan. Front row: Des Frawley, Tommy Cahill, Patsy Bray, Patsy 'Bare o' the Feet' Hickey, Willie 'Teller' Walsh and Jim Ballantyne.

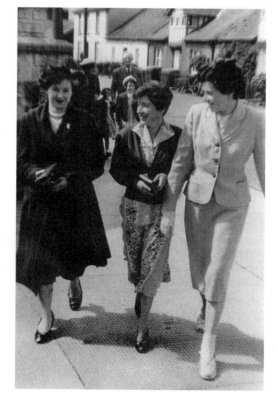

What were they talking about? Three striking Lismore ladies on the way to Mass *c.* 1957. From left to right: May Lawton, Ann O'Brien and Margaret O'Donnell.

Know all men by these presents:

Whereas **Professor Bill O'Riordan**

was admitted to the Freedom of the Worshipful Company of Engineers

on the **Eleventh** day of **May 2005**

It is hereby Witnessed:

That at a meeting of the Court of Master, Wardens and Assistants holden

on the **Twenty-eighth** day of **February 2006**

the aforesaid **Professor Bill O'Riordan**

being also a Freeman of the City of London, was admitted in proper

form to the Livery of the Worshipful Company of Engineers.

Master

Clerk

This scroll evidences two remarkable achievements by old Lismoreian Professor Billy O'Riordan. We heartily congratulate Bill. Sadly, the only advantage of the freedom of London is the freedom to drive sheep over Westminster Bridge before 8a.m.

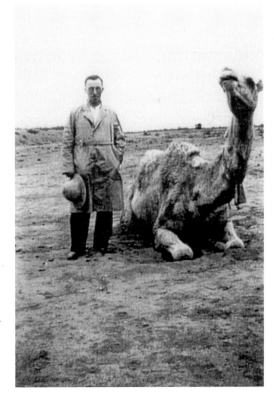

Fr James Dunne from Coolishall ran the 'biggest parish in the world' in Streaky Bay, Australia. His camel assured his more inaccessible parishioners a Sunday service and doubtless it could illustrate the danger of riches. Fr James went to Australia in the early 1920s and died in 1974.

Fr Jimmy Lane (1916-1989). From South Mall (now Owens) if born in Modeligo, Jimmy was educated in Melleray and Kiltegan. He was ordained in Rome in 1939 at the age of twenty-three and in 1950 he went to Nigeria to teach at Urua Inyang Teacher College, where the students were said to be afraid of him because he didn't talk! Recalled to Ireland in 1955, he served in Kiltegan, Cork and Drogheda and died in Baltinglass Hospital in September 1989. He was a great priest if a spectral figure, quiet as a nun, his goodness shining like an upcast flame of a dying candle.

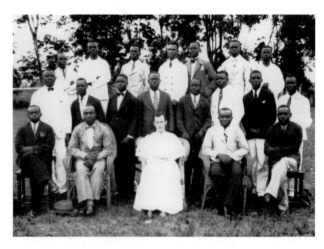

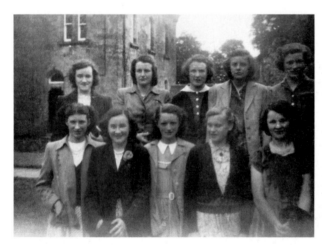

Presentation Convent Intermediate class at CBS Lismore, where they sat their exam in June 1952. From left to right, back row: Dolores Nolan, Mai Dennis, Kathleen Cuffe, Josephine Creane and Bridie Lineen. Front row: Margaret Power, Kathleen Nolan, Eily Moynihan, Mary Creane and Rena Murphy.

Class photo, Presentation Convent, 1955. Back row, from left to right: Ann Murphy (Camphire), Teresa Dahill, Margaret Moynihan, Teresa Heskin, Nora Broderick, Vera Murphy, Maria Attridge (Conna, cycled to school) and Maura O'Brien (Monamon). Front row: Ann Doocey, Breda Henley, Ena Howard, Mary Lineen, Una Carroll (Tallow) and Agnes O'Riordan (Tallow).

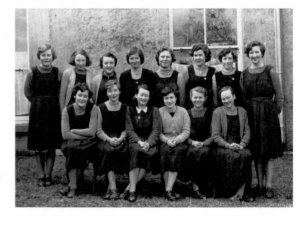

6

ARTS, SPORTS AND LEISURE

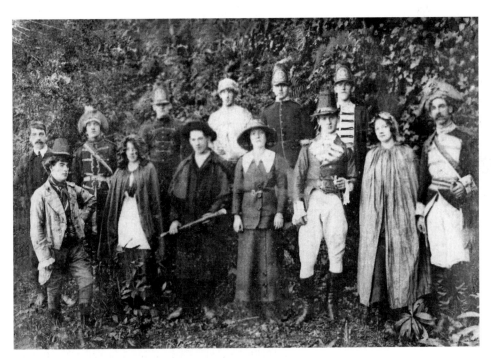

This venerable image of Lismore Dramatic Society Players in costume dates from *c.* 1918, about two decades after the society's foundation. It contains iconic Lismore names, alas many now in abeyance. Back row, from left to right: J. Willoughby, J.J. Meade (Capt. Beck), J. Gillen, J. O'Keeffe and McEnery and O'Neill (Soldiers). Front row: P. Darragh (Shaun Carey), Eily O'Keeffe (Eily O' Rourke), T. Kemp (Barney O'Brady), Annie Bible (Rose Fitz), W. Crowley (John Desmond), Teasie Meade (Nora Desmond) and John O'Grady (Lt Douglas).

'The Season's Close'

I never leave the river's side
At the season's close
Without a feeling of regret,
That saddens my repose.

I ask; each season's ending,
Now, that time moves onward fast,
May I hope to greet the opening,
Have I thrown my latest cast?

Seán O'Dooley

Writing in the 1920s, George Russell professed himself depressed at the spectacle of an Irish rural world without cultural hope or energy. The stagnant life – playing cards or pitch and toss – meant people had 'no opportunity for vital expression'! Oh yes, the pub thrived as a 1925 Commission noted, with over twice as many per capita as in Britain. Stephen Gwynn, an essayist, concluded, 'people in Ireland read very little ... talk is their literature'. Harold Speakman, an American writer, opined in 1925 that cultural life in Ireland would depend on the efforts of isolated individuals. An old argument: the individual versus society. We recall how Margaret Thatcher elevated the former. The real answer may be both, namely communitarianism.

Of course, Lismore has a long tradition in the arts, literature and music. That great Lismoreian Grattan Flood showed how the Celtic monks developed the pentatonic music scale. It is thought the tune 'Morning Has Broken' was composed in Lismore. The Book of Lismore and the Lismore Crozier speak volumes of Lismore's pre-eminence in the artistic field.

Lismore today is the beneficiary of the effects of both individuals and organisations in the arts and sport. The objective ultimately is to connect to a national movement or organisation, for example, with a dramatic society, in Gaelic games or with a great individual like Joe Whelan, 'Olympian', athletics coach and fine fisherman.

People in small towns today can, because of the communications revolution, enjoy a wide range of cultural, artistic and sporting experiences. Some will still complain they have no opportunity for vital expression. The querulous is not a group soon to be extirpated in Irish life. Our photos here give the lie to any idea of 'stagnant life' in the parish and thankfully card playing still thrives, though pitch and toss 'up Botany' or 'down the Lane' may have declined.

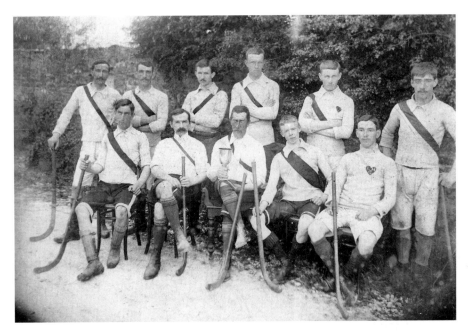

Lismore Hockey Team, 1902. Standing, left to right: ? Morrissey, ? O'Brien, R. Kirwan, Vin O'Brien, E. Egan and J. Campion. Front: J.F. O'Donnell, C.H. Stanley, M. McCarthy, ? Heffernan and W. Wall. The Irish Hockey Union developed out of the Irish Hurling Union and Ireland won Triple Crowns in the game between the World Wars.

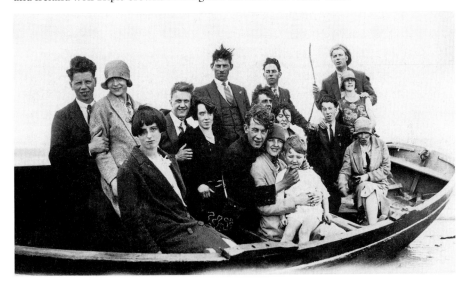

All aboard for the Youghal photo, 24 June 1929. Back, from left to right: P. Loughan (Armagh), Eileen O'Connor, Dinny O'Regan, Unknown and Jim Feeney. Sitting, left to right: Betty Murphy, Jack Barnes, Florrie Hasset, John Proctor (Arklow), Jack O'Sullivan, Norrie O'Connor (holding a child cousin), Maureen Murphy (Cork), Billy O'Gorman, Nora O'Sullivan (between Billy O'Gorman and Jim Feeney) and Sally Murphy (Nugent). Jim Feeney is likely holding seaweed, the only weed available to 1920s revellers, though the spa waters were available to 'olishers', as known in Youghal.

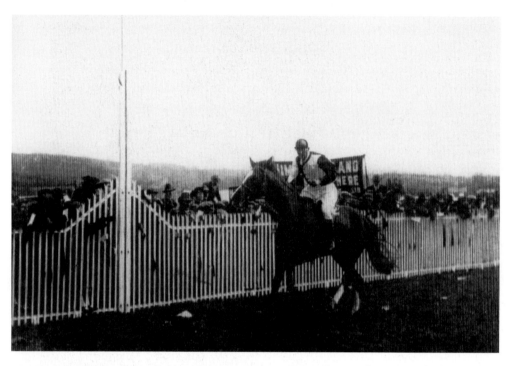

Home alone in the Cunningham Cup at Leopardstown, 1925. The winning horse was 'Old Rambler' and the jockey was Frank O'Brien. The O'Briens then owned the Red House and Frank was also an old Blackwater Rambler footballer.

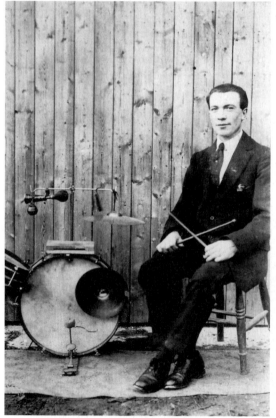

Pete Gillen Snr, Chapel Street, *c.* 1928, when he was percussionist with the Nightingale Band – a dance and jazz band popular at the time. Pete's family were gifted; his son Peter was a fine musician, Michael a talented painter and Mary a beautiful stage dancer.

Great cyclist Charlie Guest *c.* 1930 at his home (now the CU). A Lismore 'Hall of Fame' could honour Charlie as the first to bring home a national title. He went to the UK in the 1940s and worked for a long time with Boots. He died in Ripley, Yorkshire in 1974. A devout Church of Ireland member, he overcame a short-sightedness so severe that he couldn't swim without glasses.

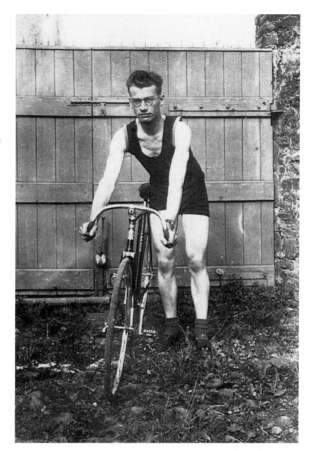

That's the spirit! Dorothy Musgrave on her horse 'Poppy', jumping a water jump side-saddle in May 1918. The Musgraves were once a prominent family in West Waterford and were imperialist, minatory and indomitable in turn.

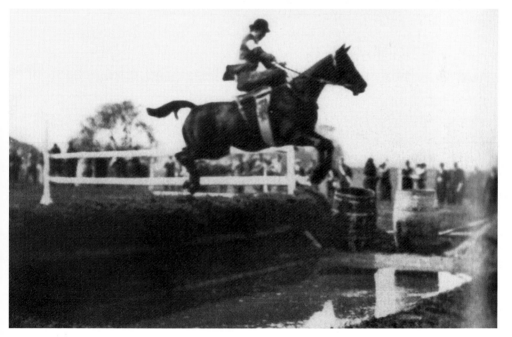

Ned Daly, hurler and teacher/headmaster (1916-2006), Lismore's only All-Ireland senior hurling medallist (1948) and runner up (1938). He was also a Fitzgibbon and triple Munster Railway Cup medallist. Ned showed early promise with 'Jack O'Donnell's' team but transferred to Dublin *c.* 1934. On retirement he devoted much effort to promoting under-age Gaelic games. He married Catherine Lineen of Lismore and reared five children.

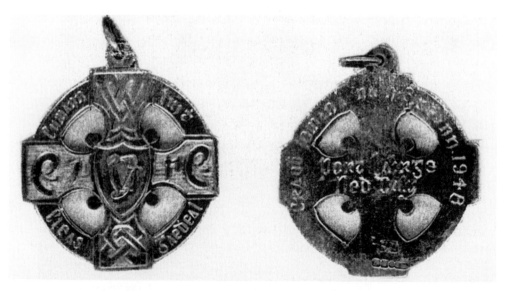

We see here both sides of Ned Daly's All-Ireland senior hurling medal of 1948.

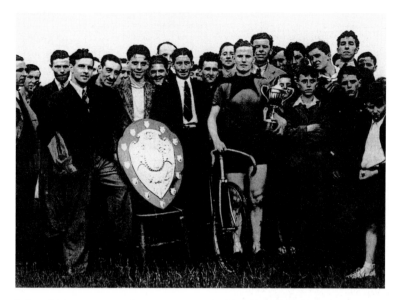

Jimmy Foley of Main Street with Matt Lennon shield and trophy in 1941. Jimmy's cycling feats were legion. In 1942, he won the five-mile Championship of Ireland and in 1945 the 7,000m title. His Munster titles came to a record forty-four between 1936 and 1949. Jimmy was also a fine greyhound trainer and he ranks highly in County Waterford's all-time great sportsmen.

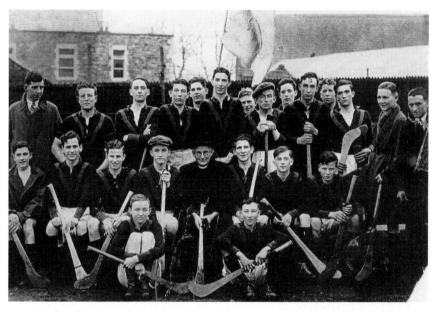

At the back of this fine photo is written, 'When we drew with Thurles CBS – I was 16' (Joe Duggan). This was the Dean Ryan Cup of 1939 at Thurles. Back, from left to right: Unknown (possibly Mr Scully, Lismore teacher), Paddy Moore, Seán Barry, John 'The Duke' Willoughby, Fr Ned McCarthy, Moss Pollard, Moss Fives, Jim Hennessy (Ballyduff), ? Fahy (Tallow), D. Savage, John Lawton, Tom Cunningham, Frank Crotty and Eddie 'Mackey' Lynch. Middle row: Fr Mick O'Brien (Knockanore), Joe Healy, Jimmy Foley, Ca Healy, Bro Duggan, Bill O'Donnell (Cappoquin), Ned 'Goncey' Foley and Billy Broderick. On ground: John Gray (Tallow) and Joe Duggan.

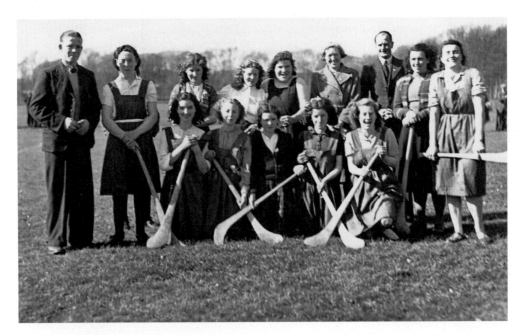

A historic snap of Lismore camogie team on Easter Sunday 1949 in the hurling field. From left to right, back row: Jimmy Power, May O'Gorman, Mary Coughlan, Alice Sheehan, Peggy Behegan, Mrs Kelly, Jimmy Byrne, Mary Daly and Josie Mangan. Front row: Maureen Dunne, Mary Nugent, Ann Mason, Irene Whelan and Delia Nugent. A golden time to be young: to be playing camogie, sheer heaven!

Jack Campion, baker, athlete and politician (1879-1953). An all-round athlete like his brother Bill, Jack amassed a large collection of trophies. His prowess is shown by his scoring of 99 out of 122 goals which helped Lismore win the Munster Hockey Championship. He also trained greyhounds and loved handball and fishing. Jack infamously (or perhaps enigmatically) hung out the Union Jack on VE Day, 1945. Jack was a person who spoke his mind. He deserves more recognition as a 'great Lismoreian', however represented.

Bill Campion, baker, athlete, fisherman, village versifier and founding member of Lismore GAA (1870-1932). Another all-round athlete, Bill excelled in the standing long jump, high jump and hop, step and jump. One of Lismore's 'Quartet of Athletes', namely C.A. Usher, John Goode, Bill and Jack Campion, who flourished at the end of the nineteenth century. A 'king of spring' surely, but Bill also had a genuine gift for simple versification.

Lismore ICA (Irish Country Women's Association) of 1962. From left to right, back row: Elaine Glasse, Mrs Glasse, Mrs John Willoughby, Nellie O'Sullivan, Mrs Corney Willoughby, Miss Creedon, Mrs Enda O'Sullivan, Mrs Dorothea Lee and Jo Lineen. Front row: Monica Noonan, Nellie Scanlan, Mrs Boyle, Mrs Bransfield (accompanist), Hannah O'Donoghue and Peg Dooley.

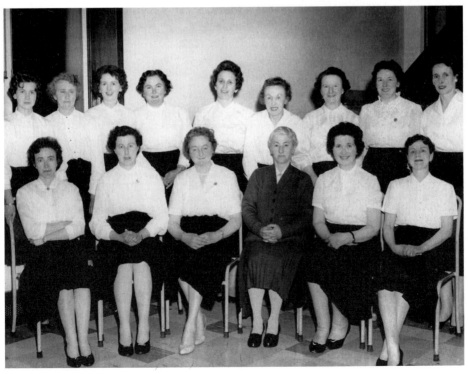

This fancy dress photo was taken in May 1954 at Lismore's An Tóstal or 'Ireland at Home' festival. On the left is Mary Kelleher of Cappoquin and from Cappoquin also, Mary Teeling. The girls came second, Elaine Glasse taking first prize with 'The Farmer Boy'. The two Marys got five bob, for which they had to apply in triplicate to Moss Pollard, Town Clerk. Now, there's suffering for your art!

At Kilworth Races, 1953. From left to right: Jim Tobin (Bishopstown), Mary and Mrs Hannah Tobin. Jim was a brother of famous athlete Ned Tobin, who visited Lismore quite often.

A recent view of Lismore Castle gardens with modern sculpture in the foreground. This walled garden with towers, terraces and battlements is the earliest garden extant in Ireland, dating from 1626. Susan Green of Melleray took this fine photograph.

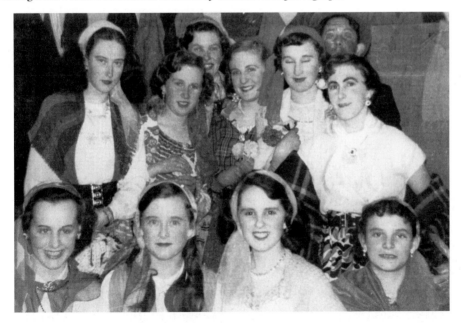

The Singing Gypsies perform at a Grand Variety concert in the Happydrome in Townspark on St Patrick's Day, 1953. From left to right, back row: Sadie Glasse, Catherine Ormonde, Josie Lineen, Carmel Gillen, Nora O'Sullivan, Ned O'Brien and Ann Quinlan. Front row: Joan Boyle, Mai Lyons, Phyllis Crowley and Tossy O'Brien. Tony Bransfield took this photo.

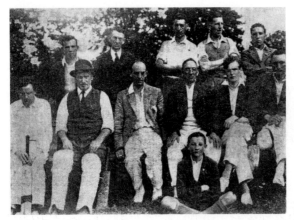

The Lismore cricket team snapped in Seafield, *c.*1946. From left to right, back row: Jim Casey, Paddy Keyes, John 'Jocklin' O'Donnell, Gordon Keyes and Joe Duggan. As far as ascertainable the front line reads: Jack Feeney, Mr May, Paddy O'Brien, Dean Stanley, Mr Jameson and Mr Duggan.

Up for the match with jaunty indifference of neutrals. The All-Ireland hurling final of 1954 which Cork won over Wexford. Back, from left to right: Jackie O'Gorman, Redmond Daly (neutral in favour of Cork), John 'The Duke' Willoughby, Billy Lineen, Mick Regan and Corney Willoughby. Front row: George O'Brien, Mick Madden and Joe O'Brien (CIE).

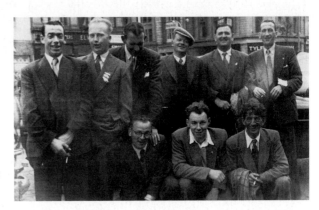

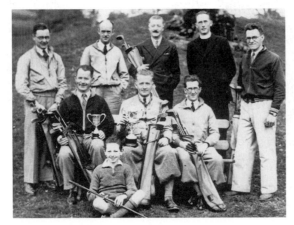

Europe was at war at the time of this 1939 photo but Lismore was laid back at the pacific game of golf. Back row, from left to right: Niall Murray (solicitor), Mr Harrington (banker), Jack Fogarty (banker), Fr Tom Tobin (brother of Jim and Ned Tobin) and Garda Michael Mason. Front row: Mr Quinlan (Garda Super), Edward Hipwell (banker) and Jack Frawley (banker). The boy apprentice (to golf and later the bank) is Dick Fogarty.

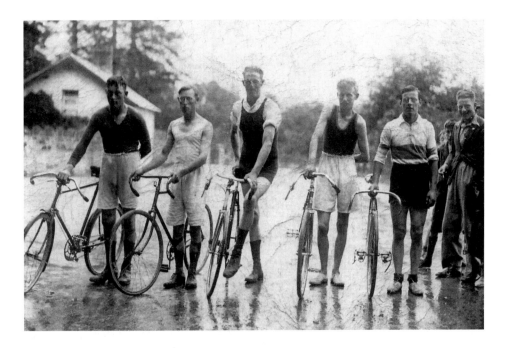

Cyclists psyching up at Ballyrafter, c.1935, for round trip to Cappoquin. The cyclist at extreme right is George O'Brien of Swiss Cottage, East End. The other cyclists aren't known. George was a formidable sportsman who sadly passed away recently in Norfolk, UK.

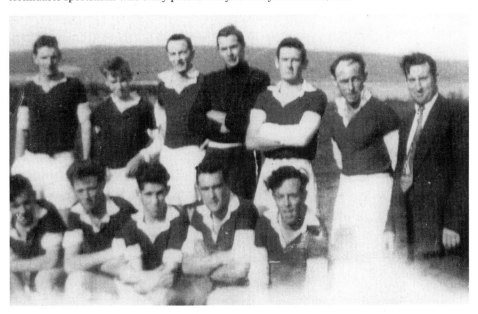

Practitioners of the garrison game in Youghal, c.1960. From left to right, back row: Con Callanan, Tom O'Sullivan, John Crotty, Trev Endersen, Eugene Dennis, Ned Doherty and Ned Barry, mentor. Front row: Noel Keating, Paul Murphy, Paddy Whelan, Billy Hogan and Pete Doherty. Lismore beat Youghal 3-1, Pete Doherty and E. Dennis 'scoring a hat trick between them', as Ned Barry said, due to Pete 'doubling' on a ball that was net-bound in any case.

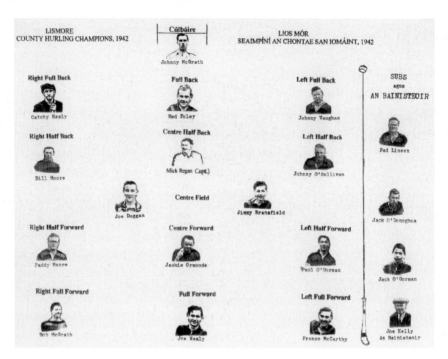

LISMORE
COUNTY HURLING CHAMPIONS, 1942

Cúlbáire

Johnny McGrath

LIOS MÓR
SEAIMPÍNÍ AN CHONTAE SAN IOMÁINT, 1942

Right Full Back

Catchy Healy

Full Back

Ned Foley

Left Full Back

Johnny Vaughan

SUBS
agus
AN BAINISTEOIR

Pad Lineen

Right Half Back

Bill Moore

Centre Half Back

Mick Regan (Capt.)

Left Half Back

Johnny O'Sullivan

Joe Duggan

Centre Field

Jimmy Bransfield

Jack O'Donoghue

Right Half Forward

Paddy Moore

Centre Forward

Jackie Ormonde

Left Half Forward

Paul O'Gorman

Jack O'Gorman

Right Full Forward

Bob McGrath

Full Forward

Joe Healy

Left Full Forward

Franco McCarthy

Joe Kelly
An Bainisteoir

This item puts together graphically the 1942 Lismore team who beat Erin's Own 2-5 to 2-3 in the Senior County hurling final but sadly lost on objection. The Lismore team wasn't photographed. A recent review awarded substitute medals to Lismore.

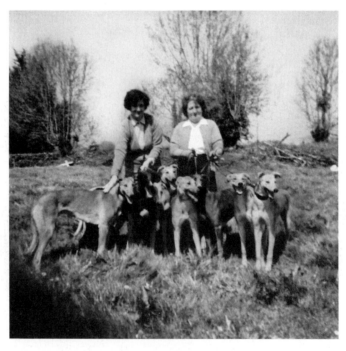

The hounds of heavenly Mayfield. On the left is Biddy Walsh, wife of John Walsh, Manager of Co-op stores. At right is Mrs Jack Greehy of Parks Road.

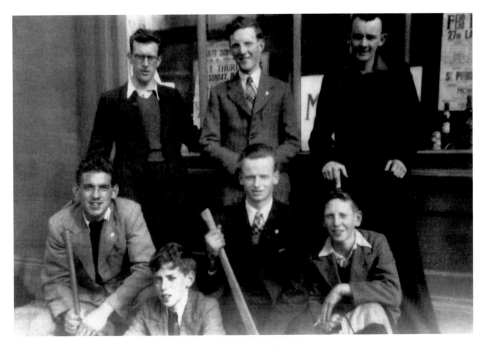

The hurling 'sevens' from 1954 outside John F. O'Donnell's on Main Street. From left to right, back row: Jack O'Donoghue, Mick Broderick and Billy Hogan. Front row: Billy Lineen, Tom Lineen, Paddy Flynn and Richard Broderick.

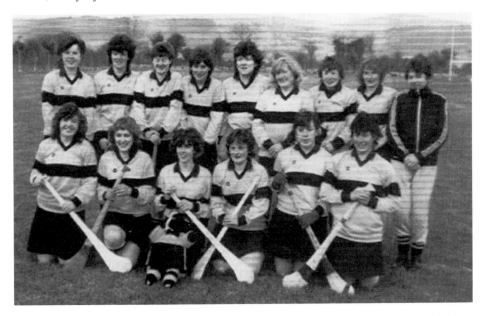

The first Lismore winners of the Waterford Senior Camogie Championship, 1985. From left to right, back row: Carmel Murphy, Sheila Tobin, Eileen Daly, Caitriona Caples, Ann Ryan, Helen Barry, Ann Marie O'Gorman, Terry Caples and Ber Crowley. Front row: Mary Murphy, Patricia Bolger, Brid Tobin, Martina Kearney, Órla Flynn and Tresa Goodwin. They were sixty years trailing the men's first Senior hurling win in 1924, but it was worth waiting for.

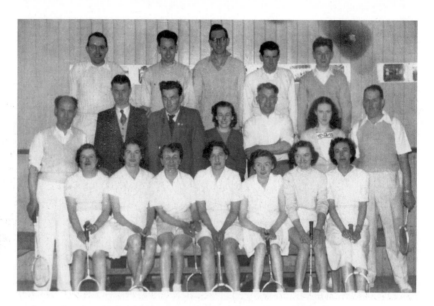

Lismore versus Cappoquin in a 'different game' in 1955. From left to right, back row: Florence McCarthy, Dick Fogarty, John Crotty, Mick Daly and Mick Fraher. Middle row: Paddy Cunningham, Bill Foley, Dick Doocey, Dorothea Daly (Lee), Jimmy Brady, Sadie Glasse and Jim Wall. Front row: Pauline Ryan, Bridie Murphy, Mary Ahearn, Mrs Brady, Justine Walsh, Helen Crotty and Monica Noonan. The 'different game' was badminton, a game in which scoring points was academic but amorous or social scoring should get a result at the end of the night.

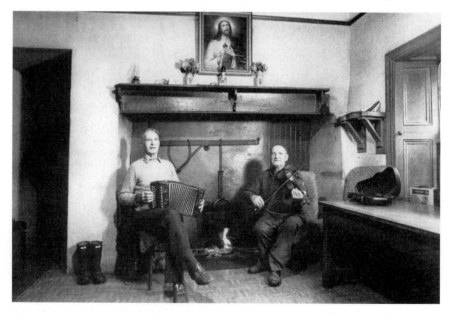

A fine study by Richard Fitzgerald of the O'Brien brothers of Ballysaggart. Mikey is the accordionist and Willie coaxes sonorous melody from the fiddle. These trusting men knew the tyrannies of upland farming and the crooked timber of humanity but music was their saviour and their balm. They lived latterly in St Carthage's Home. *Ní féidir go mbeadh a leithéídí arís ann.*

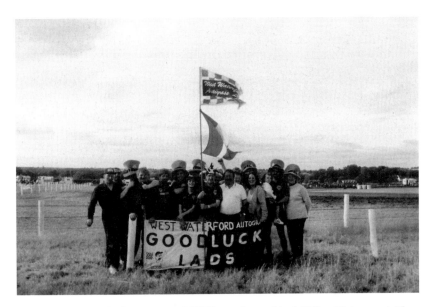

The current West Waterford Autograss (WWA) was formed in 1990 as Motorsport. The first race meeting was held in John Devine's land in Ballysaggart. The racing club was the pioneering idea of Tommy Lawless. In 1992 the club joined the Hot Rod Federation and in 1997 the National Autograss Sport Association. Family orientated, the club has been a great success.

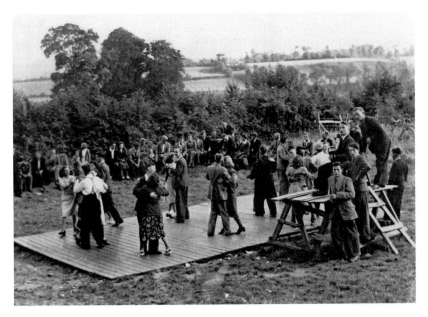

Ballygalane open-air stage of a summer's Sunday night, 1948. The three on the platform are, from left: Mattie Power, Paddy Morrissey and Jimmy Power, with Sham Power below Jimmy. Leaning on platform is Michael Doocey with Tommie Maloney behind. The man dancing with the lady in the flowery dress is local Tom Hennessey, while Pete Gillen dances with his sister Mary in white socks. Nora Nugent dances with Pakes Lynch, in cap, in front of platform. This stage was across from Cliffe's farmhouse but it later moved up to Nugent's.

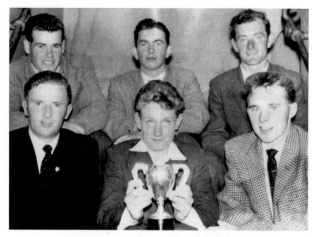

Road bowling flourished in Lismore in late 1950s to early 1960s. This was the Roundhill Tournament, which attracted about eighty players and climaxed in June after a three to four-month season. This photo shows the victory dance in the Court House in 1961. From left to right, back row: Jimmy O'Gorman (Sec.), Johnny O'Gorman (Treas.) and John Doocey (Chairman). Front row, left to right: Tadgh O'Donovan (runner-up, Cappoquin), Johnny McGrath (winner, Melleray) and John Foley (runner-up, Knockanore).

Relaxing at the Lismore point-to-point races in 1930s. The man with his back to the main party is Mike Hyde, whose family won the 1947 English Grand National with 'Lovely Cottage'. The second lady from the left is May Hickman from Ballinatrey House, a house of great racing shenanigans.

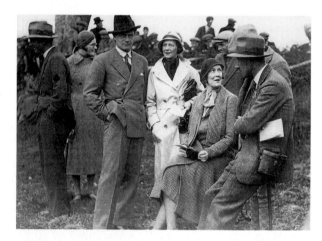

Two legendary Micks, national and local. On the left is Mick Delahunty (or Mick Del) on a Society 4 gig in the Glen of Aherlow in 1979, and Mick Greehy of Deerpark suggesting to Del that he do the blowing for both of them. Mick Del was proof that music is the condition to which most arts aspire. As Greehy said, ''Twas a privilege to be photographed with Del but to play with him – A1 silage.'

7

PARISH PORTRAITS

Dr Bernard Leddy, President of the Pharmaceutical Society of Ireland (PSI) since 2008. Born in the UK, he qualified as a pharmacist and, on coming to Ireland, he worked his way up to become General Manager of the pharmacy chain Mari Mina. He settled in Lismore in the 1980s, marrying the talented Helen Savage. A Fianna Fáil town councillor, he has been Mayor three times.

'Kate'
(for Kate Crowley, aged seventeen, killed by a train in Canada, 1913.)

A young girl nodding on a trans-Canadian train
Snaking through the cavernous Canadian spaces,
Fresh as a ripe cherry, a letter, being written fitfully home
To Ballyanchor, Lismore. Kingston, her final destination.

'Next stop Kingston' says the conductor, omitting a preliminary halt.
Kate steps out and into the path of the Toronto Express and final destination.
Such beautiful promise blighted; we cannot accommodate you in any ceremony,
To die young is not to know an opposite to appraise or lay blame by.

Out there nodding on that hurtling train
You requested a leaf from a Mall lime tree
Asked to be remembered to old school pals and wrote:
'Man and Dad and the rest, I love you-beyond all ... Kate xxxx
P.S. Canada is huge, huger than Bible's stallion ... ha! I'll never get to Maag's.
K. xx'

E.F. Dennis

The academic painter G.M. Watts said that 'a portrait should have in it something of the monumental; it is a summary of the life of the person'. Our portraits are not by Karsh of Ottawa or Julia Cameron. Julia Cameron flourished in the age of early photography and completed great portraits of people like Darwin and Tennyson. Her exposure time could seem endless and physically agonising for a sitter who had to stay perfectly still. Karsh's portraits of the famous, for example, Hemingway, with their rich textures and sombre tones, seem infused with monumental dignity and grandeur.

Our portraits cannot compete with those of Cameron and Karsh, but a number were professionally produced in studios like Doyle's of Cappoquin or Horgan's of Youghal. Most are products of box cameras, Leicas or in odd cases Instamatic cameras (which first appeared in 1962). The great virtue of 'people's photos' is their informality, which is in contrast to studio portraiture with its posing and artifice. Most of the portraits are competent, as was our aim; however, they are offered more as *aides mémoire* than works of art. The Greeks held that memory was the mother of the arts; accordingly we might proffer that portraits are its children. An old photo of an old face fills a space in the book of oblivion.

Our first Lismore photo book presented six Lismoreians who had become presidents or vice-presidents of national organisations. In this book, we add two more, namely Dr Bernard Leddy and Jimmy O'Gorman. Two extra can be added if we allow an international dimension – Monsignor Patrick O'Donnell, who was President of the American/Irish Association in the mid-twentieth century and Dr Tom O'Donoghue, who is currently President of the Australian/New Zealand History of Education Society. The eminence achieveded by this 'awesome ten' is, above all, credit to themselves and their families. Ten presidents in total: quite extraordinary! It is more than concrete evidence that Lismoreians continue to learn well where Carthage taught and that that learning 'carries'.
Jimmy O'Gorman, Chairman of the Munster GAA Council and Vice-President of the GAA.

Raised on a farm outside Lismore, he excelled in hurling, football and running. A natural public speaker, his wife Anne is blessed to have such a natural guy. Nowadays Jimmy tries to inspire the Déise into winning the All-Ireland. *Tá lá eile de dhíth go dona ag na Paoraigh.*

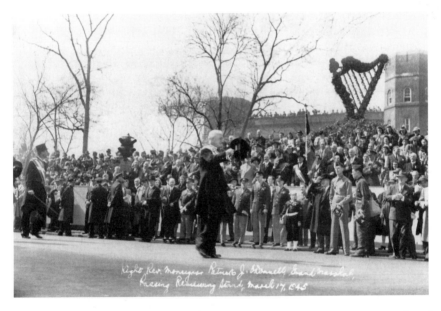

Msgr Patrick J. O'Donnell, grand-uncle of John O'Donnell now in Ferry Lane, was ordained in 1901 and went to New York as a curate. An outspoken champion of rights, he supported women's advancement and repudiated President Wilson in the context of the Irish independence movement. President of the American/Irish Association, he died a year short of his diamond jubilee. In this photo we see Msgr O'Donnell as Grand Marshall of the New York St Patrick's Day Parade, 1945, a singular honour.

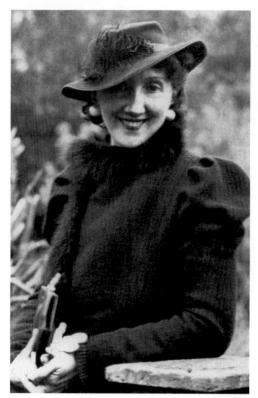

Cecelia O'Brien of the Red House, *c.*1925. This elegant lady later married the dashing retailer David 'Boysie' Noonan of the Mall Warehouse. A lady of artistic temperament, she was the mother of marine artist John C. Noonan and actress Eelagh, who married the well-known painter Charlie Brady.

The redoubtable Mrs Cooney of Church Lane, who flourished in the 1930s-1960s era. Living a chaotic life, she revelled in victimhood but was a true Brosna Queen. Rearing five resourceful children who saw her as unflappable, her old home in the lane is a long-time levelled.

A dapper Ned Tobin striding through London in 1953. Ned, from Botany, was a coerced migrant in the people-bleeding Ireland of the 1930-1960s era. Ned loved Lismore dispassionately and Botany passionately, and was a dedicated parent, although separated from his children who stayed at home in Lismore.

The handsome Dr Dan Healy on his graduation day in 1918. In 1926 Dr Healy became Dispensary Medical Officer. A GP, he was created coroner in 1952 and was also a cinema mogul. He set up the Palladium as a rival to the Mall Cinema and a sure-fire cure for recidivist patients or to obviate 'second opinion' seekers. His intention was to improve the masses through appropriate entertainment, an idea often thwarted due to a cinema discipline problem. An outstanding medic, his celbrity patients included John F. Kennedy, Harold Macmillan and the Astaires.

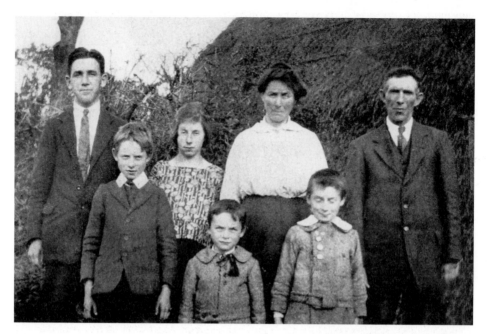

The Begley family of Cooldelane, Lismore, 1923. From left to right, back row: Eddie, Eileen, Ellen and Thomas Begley. Front row: Francis, John Joe and Jim Begley. John Joe, still as fit as a Cork flea, is the only survivor of the group. This snap captures well the 'immemorial' in the SMILE (snaps, momentous and immemorial of Lismore and environs) project.

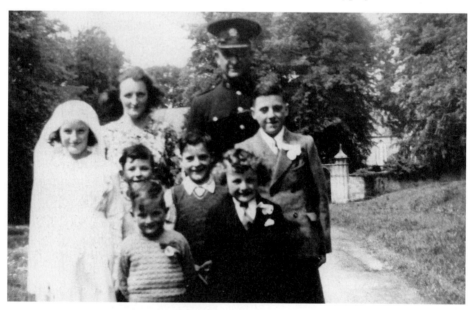

North Mall invasion, June 1947. From left to right, back row: Mrs Mary Helen Dennis and Garda James Dennis. Middle row: Mai, Eugene, Peter and Seán Dennis. Front row: Dermot and Michael Dennis. The 'great occasion' was Confirmation for Seán and Mai and First Communion for Michael and Dermot. The Church of Ireland peeps through and the old lime trees still bloom, though removed in 1949.

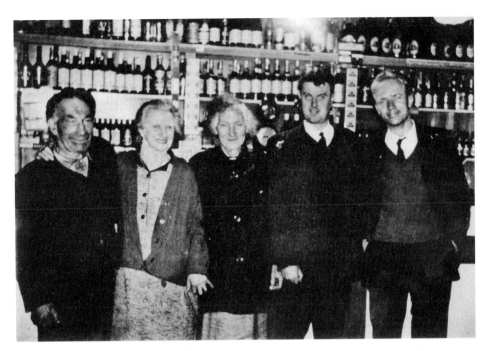

The Classroom pub, as it is now known, in Foley's era. From left to right: Dick 'Cabhraí' O'Donnell, Mrs Foley, Lil Ryan, Bill Foley (proprietor), and Dick McCabe (O'Donnell's Yankee cousin). Foley's was a traditional Irish business combining a pub and grocery.

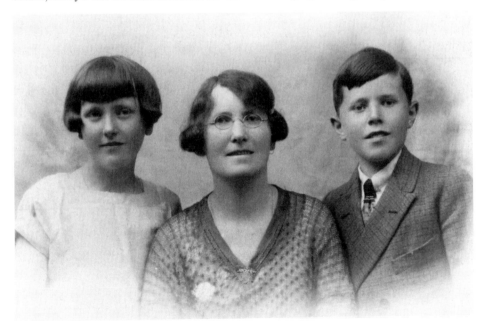

Mrs Quinn from Chapel Place in the late 1920s with her two children Mai and Paddy. The Quinns were a great tailoring family. Mai got married and her daughter Carmel is still living at Chapel Place. Paddy joined the Gardaí in 1939, serving out his career in Dublin. Sadly, Mai died in March 2010.

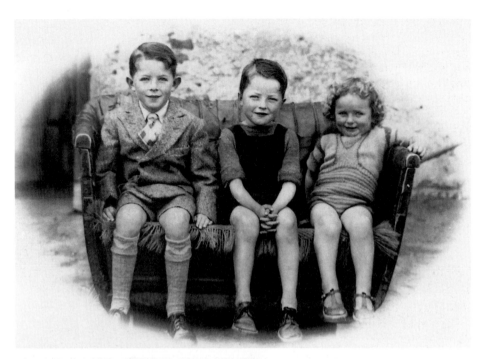

The Foley boys, sons of Johnny and Nell Foley, Parks Road, snapped on Bing's First Communion day in 1945. From left to right: Bing, Val and Pat.

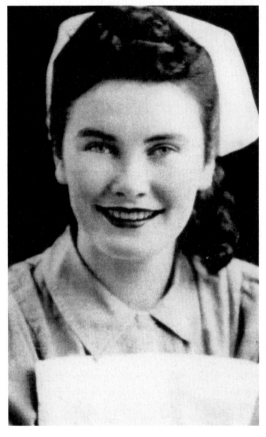

Cailín gleoite on a beautiful day. Phyllis McGrath of Monatrim qualifies as an SRN (State Registered Nurse) in 1951. Phyllis later became Mrs Lee in the UK. Phyllis's progress mimics that of thousands of Irish girls who took up the nursing profession in the UK in the middle decades of the twentieth century.

Patrick O'Shea was born *c.*1880, the son of the O'Sheas who ran the pub which is now The Classroom. He became a professional singer and won first prize in the Oireachtas of 1898. A lyric tenor, he pioneered the introduction of the great Irish language melodies to the concert platform. Pat toured widely, married an Italian lady and had three daughters. Sadly, he developed throat cancer and died young. He is buried in Glasnevin Cemetery.

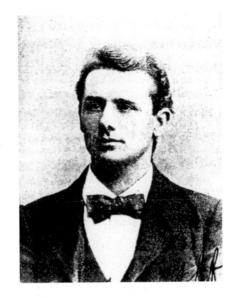

Portrait of 'Bun' John Heaphy of Lower Botany from the 1930s. 'Bun' was a son of Jackie and Mary Heaphy. The Heaphy family included artisans of high skill, Jackie being a stonemason. Others of the family were Moss, Dan, Nell and Jimmy, who was a freedom fighter. Bun married Esther Fitzgerald of Ballyduff. He ran a chip shop in East End during the Emergency. Bun left with his family for the UK at the end of the 1940s.

Seoirse or George O'Brien, writer, and professor at George Washington University, Washington, USA. His *Village of Longing*, a Lismore memoir, is his *magnum opus* on a baile beag. The memoir often blurs the borders between fact and fiction and might better be called 'creative non-fiction'. An occasional slip or sweeping assessment may have caused local disgruntlement but, in general, O'Brien wields a dispassionate pen.

Portrait of John Noonan taken in Chapel Place in 1962. A veteran and casualty of the First World War, John was philosophically minded – witty if curmudgeonly. A painter, he urged people to be creative but to join nothing. He was a natural agnostic: secular and spiritual. This photo was taken by his cousin Hamilton Delargy, nephew of the famous Professor Delargy, Director of the Folklore Commission.

The Moores of Claughaun, Ballysaggart, c.1930s. From left to right: Pat, Kate, Mike, Bill and John. Seated is Daddy Moore. Missing from the photo is younger sister Bridie. The haystack provides a contrastive backdrop that the great portraitist Karsh might envy. Old Lismoreians will recall John Moore's once fine grocery and newsagent's on Main Street.

Townspark, Lismore, July 1944. 'The Murphy Four' in their garden haven. From left to right, back row: Rosie and John. Front row: Pat and Vera. Peter Murphy was a genial member of the Garda Síochána who, with Mrs Murphy, reared a family of high flyers. Sadly, Rosie and John have now passed on. Pat lives in Scotland and Vera in the UK.

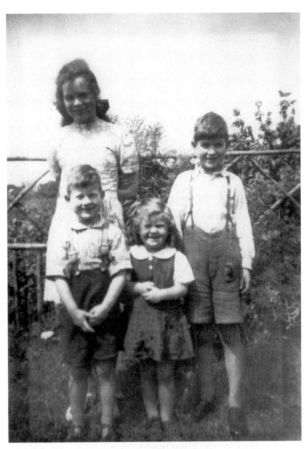

Major Walter (Waltie or 'Wattie') Cullinane and his wife Bridie (*née* Coleman, Cappoquin) snapped in the early 1940s. Born in 1891, Walter had distinguished service with the Unites States army before retiring to Hill Cottage, the former home of Danny McCarthy. Walter was slightly eccentric in his square bashing walk and occasional appearance in khaki army uniform; mostly he moved about, hands behind back, half-whistling, half-murdering some poor tune.

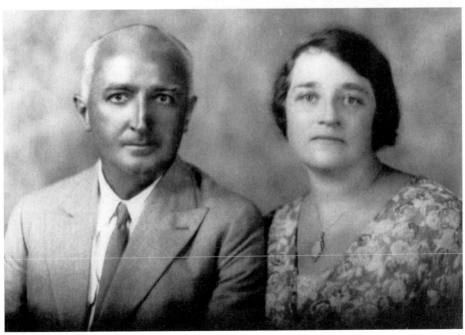

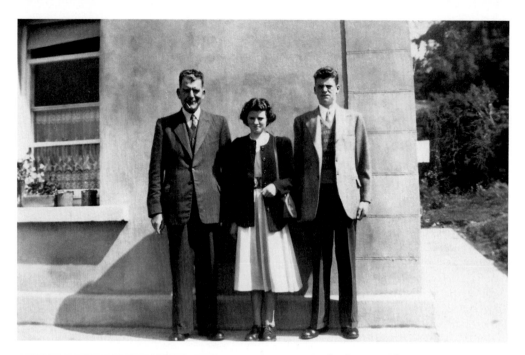

Garda Chris Houlihan on holiday in his old home in County Clare in the 1950s with his daughter Teresa and son Michael. Teresa still lives in County Cork. Michael emigrated to the US but sadly died young.

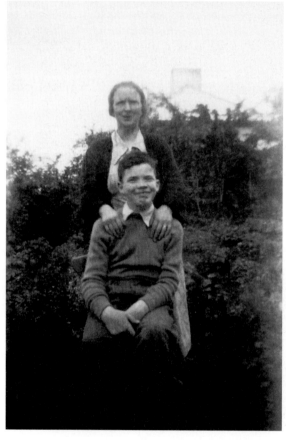

Mrs Hickey and son Francis in 1952 in Deer Park. Francis was victim of a horrific car accident in 1946 on the Tallow Road. Thereafter, his life and those of his carers was heroic.

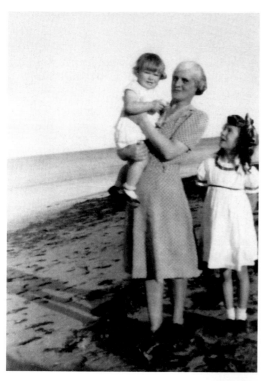

It's Youghal Strand in summer 1943, but wee Breda Power isn't happy. Holding her is Mary McGrogan, a well-known dressmaker in her day who latterly lived in Chapel Street before she moved to Limerick. Margaret Power looks on consolingly.

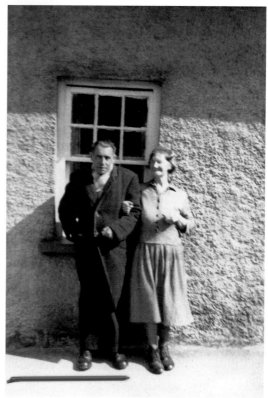

Jim 'Slog' Ahearne and Nell Heaphy in front of Nell's house in Lower Botany in the 1960s. Jim is part of local folklore, Nell less so, but by association she can share folklore's main increment – immortality.

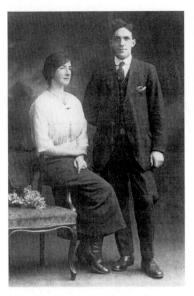

A swell couple from the 'roaring twenties': Mr Tom Lineen and his wife Catherine in a studio portrait. Tom, a social security officer, raised a high-flying family: Catherine, Bill, Eileen, Jim, Tom and Mary. Tom, a county engineer, was a brilliant hurler who won a County Kilkenny senior club medal and excelled, too, at the unlikely game of hurling-handball.

A dapper Joe Kelly and his daughter Myra at their home in Chapel Street in the mid-1930s. Joe was a doyen of the great Ramblers' era and a bainisteoir into the mid-century. Sadly, Myra died quite young. Joe later opened a shop and boarding house at the photo site.

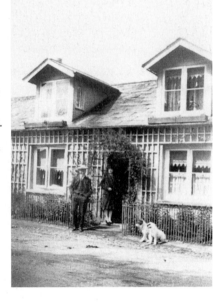

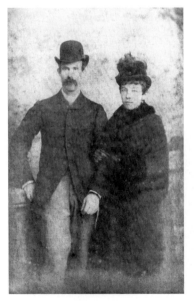

This portrait was taken in the Lawrence Studios in Dublin in the early 1930s. The couple are Edward Murphy and Mrs Murphy of the West End drapery. 'Dapper' comes to mind, but more the elegance and refinement of a bygone era.

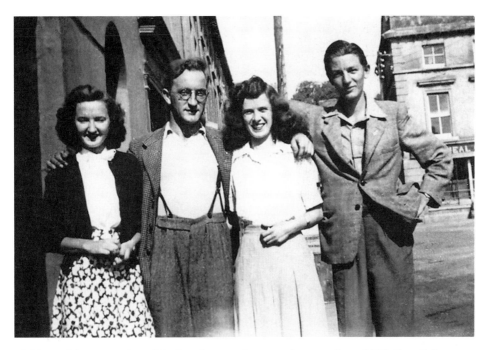

Children of the grocers' republic, handsome to boot, on the main drag, 1950. From left to right: Helen Crotty, Ca Healy, Carmel Foley and John Crotty. Note the Knockmeal Stores on the right. John Crotty still lives in the old home while Healy's Arcade is disused and Foley's is now The Classroom pub.

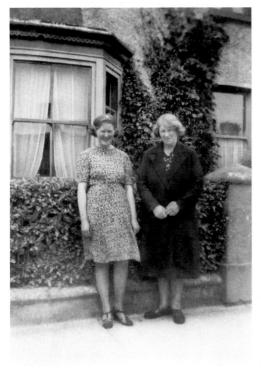

Mother and daughter in front of their South Mall home in the 1950s. On the left is Josie Fogarty and to the right Mrs Fogarty. Michael O'Leary now lives in this house. The Fogartys were a banking family whose business was money and whose pleasure was golf and no-one then felt handicapped.

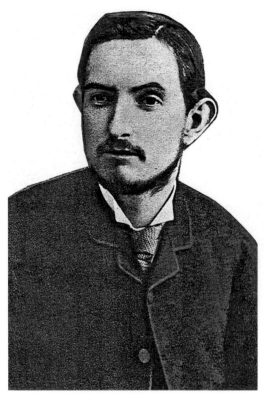

Maurice Healy MP, 1859-1923. Son of the clerk of Lismore Union and wife Eliza, Maurice was educated at Lismore CBS. He contributed hugely to land reform and to finance, labour and other legislation. Parnell cited him as the real architect of the 'land question'. His son Maurice was auditor of the L&D at UCD, won an MC in the First World War, and wrote the classical legal memoir *The Munster Circuit* about roguery and rogues – mostly lawyers!

The three captivating daughters of Jack and Minnie Nugent in Townspark, *c.*1950. On the left is Joan in quasi-hoodie attire, with Mary behind and Noreen on her trike. To the rear is a good view of the old railway bridge which was always the first bridge Lismore emigrants had to cross as they left unblighted for Blighty.

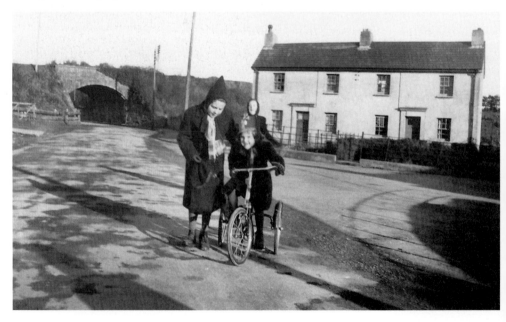

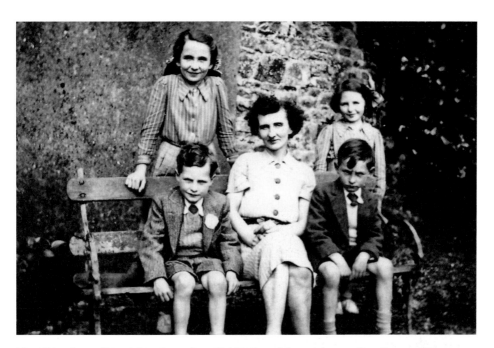

The O'Riordans of East Main Street, late 1940s. From left to right standing: Betty and Berry. Sitting: John, Mrs O'Riordan and Billy. It was John's First Communion day. A banking family, only John now lives in Ireland; Betty is in Canada and Billy and Berry are in the UK.

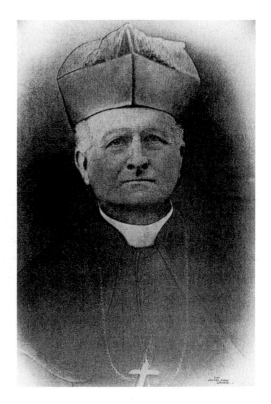

Archbishop Robert Dunne of Brisbane, 1830-1917. Robert was born at 79 Main Street. Educated at Lismore Classical Grammar School and Melleray. After ordination Fr Robert went to Australia, becoming Bishop of Brisbane in 1882 and the first Archbishop of the same city five years later. He made a remarkable contribution to Catholic education in Australia. Though traditionalist and conservative by nature, Robert easily deserves a plaque at his birthplace, which is now incorporated into the Red House.

Two nice boys from a fairly innocent age. On the left is Philip Foley of Round Hill or Ballyea and with him is Bobby Fraher of the same townland. The photo was taken behind Michael Byrne's cowshed in 1956.

Sitting pretty at the 'milestone seat' opposite the Monument, c.1960. From left to right: Mick Bransfield, Moss Heaphy, Mary Moynihan and William 'Badger' Crowley. Mick and Moss were two talented artisans, 'Badger' a returned yank and old Blackwater Rambler. This seat never attracted a definitive name. 'Badger' loved the site – we suggest it be called 'Badger's seat'.

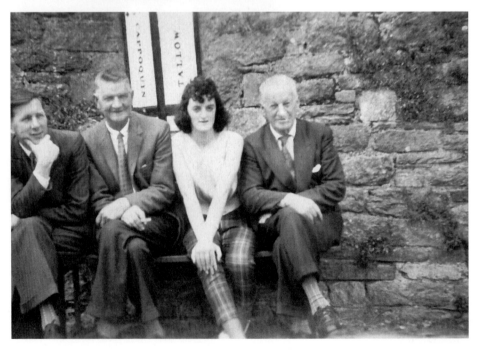

8

THE SCENES AROUND LISMORE

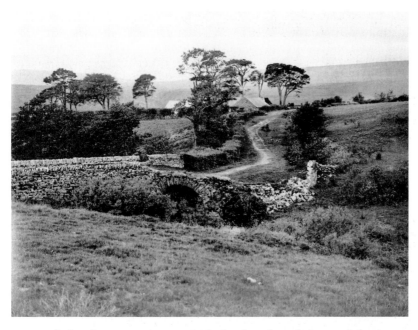

A scene at Crooked Bridge, Carrignagour, 1945. That famed crooked man of the rhyme must've deployed his talents here, but nothing to daunt our own gobán soar. The farmstead in the photo is Nugent's, which is now abandoned. The Crooked Bridge has been straightened out, if not literally.

'Tis sweet to sit at even time
And view the Castle grove,
But sweeter far in summer time
Its shady paths to roam,
I've travelled most the South of France
The Alps I did explore,
Of beauties rare, they have their share
But cannot touch Lismore.

The Blackwater flows so gently on
To swell the deep blue sea,
Its beauteous course, behold for miles
Till hidden by Kilbree,
The Comeraghs in the distance
To heaven, seem to soar,
Artists paint, but very faint
The scenes around Lismore.

But hark, what rustling noise I hear?
It is the Owennashad.
A stroll along the Lovers' Walk
Would make your sad heart glad.
To see those rustling waters,
The rocks come tumbling o'er,
No scene you'll meet can ere compete
With the scenes around Lismore.

The scenes remain but where are they?
The friends of boyhood's years,
With whom I played before I knew
This world of bitter tears.
Yes, some have gone to foreign lands
And some to Heaven's bright shores,
And I ochone, must view alone,
The scenes around Lismore.

William Campion

The final chapter is about portraiture, with reference to the landscape and the built environment – the hinterland in effect. Travel writers write of 'nostalgia for Africa'. It has its counterpart; nostalgia for Ireland, especially one's home-place. It's a contagious if harmless spell for which its sufferers don't really want a cure. It makes even the least sensitive linger over small details and resourceful profiles. It's a balm in a world of ever urgent (to coin a phrase) 'futuristic nowness', which unwittingly is inducing us into a permanent social hysteria. In Lismore's case, the hinterland has the bonus of being uniquely scenic, historic, and immemorial.

We all need a place where peace drops fast, not slow, and in mega measures, some retreat that resonates with the soul's biography. Lismore fits that bill to a tee. Bill Campion's fine ballad above dates from the 1920s. Bill would now hardly recognise Lismore but defining scenes are immutable. The raucous obscenities of crows in the rookery are still a feature. Liquorice allsort trees in their stockings of moss still balance teeteringly above the curling Blackwater along the Grove and Warren. The mad mountain tumbler, the Owennashed forever coolly elides with the 'Irish Rhine' below Ivory's bridge. Reclining in the grace of nature's bounty, one feels a rising optimism, the perfect 'stay-cation' for Lismoreians. *Éireann go brách ach Lios Mór idir an dá linn! Sláinte!*

A view of Chapel Place in the 1950s. First on the right we see the Iron Room, which John Scott Allen used as a workshop. The adjoining building was once the Mechanics Institute and then a News Room where papers were available. At the time that the photo was taken it housed a Billiard Club with the option of radio listening. Its most recent reincarnation is as a St Vincent de Paul headquarters,

The lady by the lake. The serene young lady is Enda Whelan by Bay Lough in 1928. Enda reflects no fear of Petticoat Loose, a Rabelaisian type whose ghost haunted the place until banished to the lake's bottom. Undaunted, Petticoat darted from her weedy basement to haunt fisher folk and swimmers.

This photo of seeming inertia in the Lower Lane from 1973 captures a hidden turmoil: the houses to the left in the final throes of decay, the no-surrender of Ned Murray's garage and the undying optimism of Tommy Parker's pants drying in the wind-inducing portico. This part of the lane is now blossoming, as Seoirse's cabins become *des res*; a quiet backwater where hope and folklore rhyme.

Michael Whelan, son of 'Olympic Joe', squats aloft the Araglin waterfall at Seemochuda. Clever fishermen like Mick have long kept this special place a secret. The falls are halfway between Clogheen and Ballysaggart in the Knockmealdowns, in a place called the Three Doons in the Foildearg.

Jackie White lived in Church Lane but removed to a cave in the Warren in the 1930s. John Noonan's cartoon captures him preparing his habitual fry-up in front of his *des res*. Jackie has entered Lismore folklore. His favourite three-word saying, 'no nor won't', still survives in the form, 'No nor won't says Jackie White'.

The 'Holy Fella' Br Romould (Terence) Higgins and the 'Long Fella' Éamon de Valera on a walking tour around Lismore in the mid-1920s. Br Romould taught at Waterford De La Salle and wrote for *Poblacht na hÉireann*, an early consciousness raiser. Dev, 'the tall boy from Brooklyn who did well in Ireland', had holed up in the Lismore area in the Civil War, once hiding in the folds of a Tourtane lady's skirting. The background 'soldiers of the rearguard' make the photo compelling.

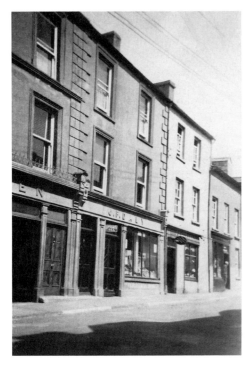

A capturing of the eastern side of Lismore in the late 1940s. Note the fine shop frontages. The last premises in view is Lowe's chemist shop, with Bob Lowe at the door. The name Lowe is now long gone but was once prominent in the medical profession. Bob's sister Elizabeth, a veteran nurse of the First World War, was the first lady to ride a bike locally, a pursuit which scandalised many by all accounts.

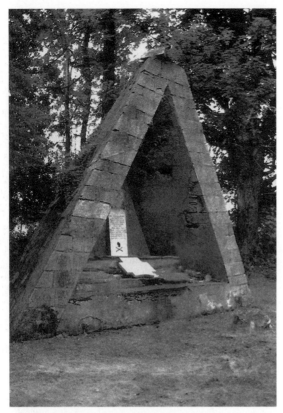

This cenotaph is in St Declan's Cemetery or An Reilig in Dromroe. It was erected by Sir W. Homan and his wife in 1821 in memory of their son who drowned saving Mrs Homan. Called 'the pyramid' locally, in fact it represents a sinking ship. John Kiely (Ussher) built the monument. Said to be the birthplace of St Declan, traces of the old church are still visible.

This is a simple marker of Ballysaggart red sandstone in memory of an unbaptised child, St Declan's cemetary having many. A dead, unbaptised child carried a stigma. Parents would bury their child in the dead of night in secret in forbidden consecrated ground, with any siblings and most neighbours being unaware of the matter.

A painting completed by John C. Noonan for use in this book. The scene captures the old coach road over the mountain, where towns were connected, by the Bianconi coaches, for example.

John F. Kennedy visited Lismore perhaps twice after the Second World War, though there is no photographic evidence. Finola Healy, daughter of the eminent Dr Dan Healy, recounted to the author of how she called to see her dad at the hospital one day. There she saw the charismatic J.F.K., who had a hospital appointment or medical need interacting gleefully with local children. We must thank Finola, as John Noonan's cartoon is useful compensation for the photographic deficit.

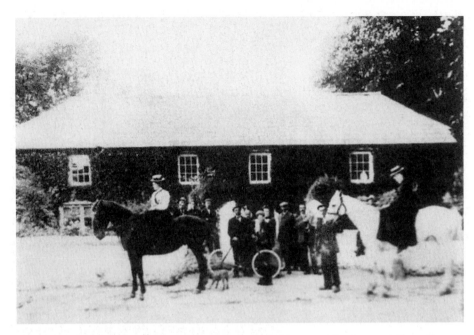

This photo of the Glencairn Inn is from early twentieth century. The Inn, now Buggy's, dates back to the 1600s. It was owned by the O'Donoghues at the time this photo was taken. Note the side-saddle-riding ladies and the gentleman with trusty bike.

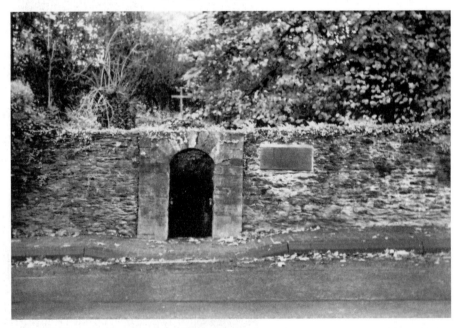

Site of St Carthage's Well or Tobar Chárthaigh. St Carthage was the founder of Lismore and is the town's patron. This entry to the well is new, though the well's original position is where the new children's playground is; this is really the Forge Well. The patron's day is 14 April and the saint's holy water is said to relieve eye trouble (but evidence-based adherents recommend an optician).

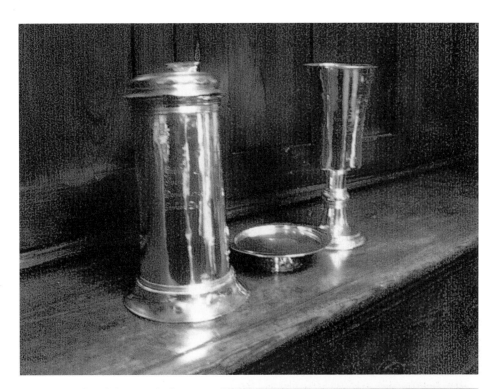

Three examples of the inscribed communion plate of the former Diocese of Lismore, held by the Church of Ireland, Lismore, namely a flagon, paten and chalice. These antiquities greatly enhance an already wondrous cathedral.

Here we see an image of one of the treasures of Lismore Church of Ireland Cathedral. It is an official seal dating back to the seventeenth century. This ancient seal also puts the deal on our journey into Lismore's past. *Sos maith mar sin agus slán agus beannacht.*